LORCAN O'HERLIHY

CONTEMPORARY
WORLD
ARCHITECTS

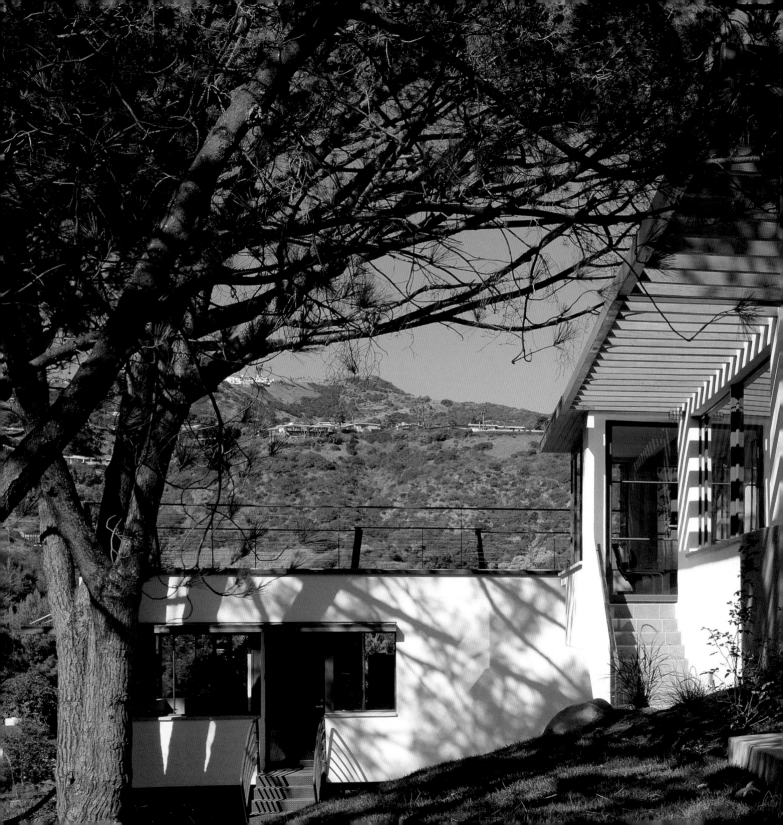

LORCAN O'HERLIHY

Foreword by
Anthony Vidler

Introduction by
Edward Dimendberg

Concept and Design by
Lucas H. Guerra
Oscar Riera Ojeda

First published in the United States of America by:
Rockport Publishers, Inc.
33 Commercial Street
Gloucester, Massachusetts 01930
Telephone: 978-282-9590
Fax: 978-283-2742

Distributed to the book trade and art trade in the United States of America by
North Light Books, an imprint of F & W Publications
1504 Dana Avenue
Cincinnati, Ohio 45207
Telephone: 513-531-2222

Other Distribution by Rockport Publishers, Inc.

ISBN 1-56496-504-X
10 9 8 7 6 5 4 3 2 1
Manufactured in China.

Cover photograph: Kline Residence by Conrad Johnson
Back cover photographs: Kelly Residence by Tom Bonner (Top),
Harriet Dorn Women's Clothing Store by Grey Crawford (Bottom)
Back flap photograph: Lorcan O'Herlihy by Cornelia Hayes O'Herlihy
Pages 1-3 photograph: Freund-Koopman Residence by Tom Bonner

Graphic Design: Lucas H. Guerra/Oscar Riera Ojeda
Layout: Oscar Riera Ojeda
Composition: Hunha Lee

CONTENTS

Foreword

BY ANTHONY VIDLER

In defiant defense of the democratic and social aspirations of modernism against the Nazi onslaught in 1933, the architectural historian Emil Kaufmann wrote his celebrated book *Von Ledoux bis Le Corbusier*, which traced the rationalist idealism and formal abstraction of the modernists to their Enlightenment (and utopian, if not republican) roots. Ending the book on a significant note of emigration, Kaufmann, not long before his own forced exile from Vienna to the United States, was optimistic that the ideals of the Modern movement were, while shadowed in Europe, alive in the United States. In particular they thrived in California, in the hands of Richard Neutra, represented by his recently published book, *Wie baut Amerika?* (1927). Modernism, abstraction, and democracy—in Kaufmann's terms—had found a safe and nurturing haven on the West Coast.

In the years since 1933, of course, this optimism has been unevenly confirmed. A social utopia translated into style, and styles succeeded style from modernism to art deco to the always more popular traditions of Spanish, Tudor, French Renaissance, and the like. Recently, however, there have been a number of signs that a new generation of unrepentant modernists are at work, and not only in the post-dada and post-constructivist modes espoused by architects from Frank Gehry to Eric Owen Moss and Morphosis or the filmic modernisms of Hodgetts and Fung. For, following these mid-career architects, a group of younger designers have developed less ideological, formally quieter but equally committed practices—practices that work hard to fulfill the functional promises of modernism, that attempt to join a minimalist but not ascetic approach to a delight in the sensuousness of natural and artificial materials juxtaposed in clear, rational, and light-filled spaces. And of course, it is the light—the kind that Le Corbusier encountered in the Mediterranean and could only dream of in Paris—that makes California modernism a fulfillment at least of the "light, air, and greenery" axioms of early masters.

In the work of Lorcan O'Herlihy, a significant emerging voice in this new generation, the faith in modernist reticence, in abstraction, in "white" architecture, is mediated through a contemporary sense of inventiveness in the use of materials, traditional and new, and a profound understanding of context, its landforms, vegetation, and above all, light. Taking his cue from the spatial organizations of Loos, Schindler, and Neutra, O'Herlihy deploys his intersecting volumes to take advantage of the often panoramic views, floods of light, and dramatic sites he occupies. And if for the West Coast, the equivalent of modernism's "Mediterranean" would be the simple stucco cubes of the early "Mission" buildings, so O'Herlihy echoes the traditional play of wood and plaster in a combination that exploits the "new" woods and their golden, light-distributing surfaces—birch- and maple-faced plys—together with a judicious utilization of high-tech motifs and materials in order to provide a contemporary substitute for the "built-ins" common to Neutra and his followers.

The design for the Harriet Dorn clothing store in Gehry's Edgemar development in Santa Monica shows a microcosm of his method; here in the small space of two hundred square feet (twenty square meters), a combination of elegant built-in cabinet

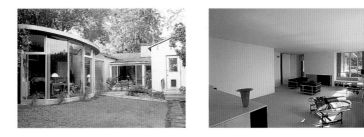

work, designed as a folding screen of birch, is set in a vertical volume topped by an inverted parachute hung beneath the skylight to diffuse the light, like some upside-down Fortuny lamp, with hanging-racks suspended on long rods as if a prosthetic part of the sky itself. The effect is of a giant, white, translucent flower, turned up to the sun, sending down its slender roots in the form of steel tendrils to capture the clothes below a fantasy of "sky hooks" characteristic of 1920s Constructivism and Expressionism but reframed in a contemporary guise.

Perhaps the most effective demonstration of this approach is, not accidentally, to be seen in the restoration of the Beckstrand/Goldhammer Residence, originally built in 1940 by Neutra, Kaufmann's hero of West Coast modernism. Rather than restoring the house as a museum of its former self, O'Herlihy intervened subtly, reframing the spaces and fittings so as to produce an entirely contemporary, yet fundamentally modernist dwelling for its new owner, David Goldhammer. White "primitivism" was replaced by delicate birch cabinetry; Neutra furniture supplemented by the work of Le Corbusier, Mies van der Rohe, and Frank Gehry; small cubic rooms opened up to each other in flowing spaces, themselves opening to the view; the view itself, once natural, now occluded by adjoining development, shifted and reoriented toward the ocean. The house, as a whole and in its parts, stands as emblematic of a practice that holds the promise of developing, in the 1990s, into a significant critical reappraisal of the 1920s. But, as with most successful reappraisals, Lorcan O'Herlihy Architects has already contributed a significantly original cast to the light-filled, spatially open, material culture of the West Coast.

The elliptical master bedroom volume of the Holland Residence (top left) creates a courtyard area, making use of a traditional Southern California typology. The Beckstrand/Goldhammer Residence (top right), originally built in 1940 by Neutra, has been subtly impacted, reframing the spaces and fittings so as to produce a contemporary environment. The new bedroom/library wing of the Freund-Koopman Residence (left) "hovers" over the descending hillside, with its prismatic library volume on top.

Introduction

BY EDWARD DIMENDBERG

The innovative formal solutions and elegant simplicity of Lorcan O'Herlihy's buildings in Southern California evoke the traditions of West Coast modernism, yet this architect is an improbable candidate for assimilation to a single line of descent or tendency in architectural history. Born in Dublin, raised in California, and having practiced and taught in Paris and London, O'Herlihy cannot be assigned to a single national tradition and his work fits uncomfortably under the rubric "Los Angeles School." As a member of the design team on Pei's Louvre renovation and as an instructor at London's Architectural Association, he confronted firsthand the challenges attendant upon designing buildings for the dense fabric of the traditional metropolis that commentators dutifully remind the world Los Angeles is not. O'Herlihy's cosmopolitan biography and broad range of formative experiences make him an apposite figure for inclusion in a book series titled *Contemporary World Architecture*, and the publication of the present volume provides a welcome occasion to reflect upon his achievements to date.

When Martin Scorsese mentioned borrowing a scene from one of Jean-Luc Godard films, Godard replied, "It's not where you take it from, but where you take it to that matters." O'Herlihy's architecture makes no pretense of escaping from history, and its singular value lies in the new directions in which it extends the vocabulary of modernists such as Irving Gill, Louis Kahn, Richard Neutra, and Mies van der Rohe to contemporary residential and commercial building programs. His work both renews our engagement with modernism and enriches the built environment of Los Angeles. It is difficult to comprehend this when reading about O'Herlihy's buildings in architecture publications—how I first encountered them—for like most instances in which a practitioner's work is shown reduced to text and photographs, they inevitably decontextualize it, omitting the urban matrix to which his work is a quietly provocative addition. At its best, O'Herlihy's architecture interacts with the fabric of the city in subtle and frequently unpredictable ways and reminds us how even a single building retains the capacity to alter the metropolis and allow us to experience it anew.

At a moment when Los Angeles has emerged as the showcase for numerous significant large-scale commissions (with more to come in the next century) and as the home to the largest group of young practicing architects in the country, its architectural culture frequently seems to ape the culture of the entertainment industry that long has served as one of its main sources of patronage. Styles, programs, and building solutions circulate like so many genres of the film studios, endlessly repeated yet slightly varied so as to produce the novelty requisite to bring architectural clients to the box office. A deconstructivist mini-mall? No problem. Offices with brightly colored corrugated metal walls for a small film company? Easy. Elegant modernist villa condominiums with underground parking? Coming right up. Nowhere else in the world has architectural modernism been bought, sold, and packaged with greater enthusiasm, like so many varieties of candy at the cinema multiplex. And nowhere else does the risk of modernism's degeneration into an accouterment of consumerism and the culture industry weigh more heavily upon the architect.

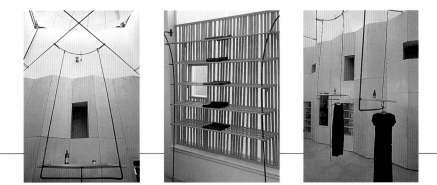

Herbert Marcuse, the only philosopher of the Frankfurt School to have settled in Southern California with a modicum of contentment (his colleagues Theodor Adorno and Max Horkheimer eventually returned to Europe), possessed an unusual gift for capturing the cultural resonances of his new home in pithy formulations. "You tell me that you are happy," he once said to a student at the University of California, San Diego. "And I tell you that you are not." Analyzing contemporary Los Angeles architecture requires a peculiar knack for registering the disparities between the buoyant rhetoric of the city's self-representation and the more invidious metaphorical functions served by its recent constructions. O'Herlihy's work displays a complex mode of engagement with its environment, one that rejects the alternatives of simple negation or affirmation. To encounter his projects is to discover buildings that resist the imperatives of neoclassical boosterism, solipsistic formalism, commodified nostalgia, or facile references to mass culture. It is to discover an architecture that embraces the properly architectural task of place-making.

In the last few decades of the twentieth century, Los Angeles has experienced a boom in construction, and a concomitant growth of architectural clichés. Anyone who once believed that stylistic eclecticism and historical appropriation would liberate architecture from the oppressive strictures of modernism could well find himself or herself growing wistful for the *ancien regime*. Individual eccentricities, particularly evident in the decorative treatment of façades, flourish in a culture of novelty that places a high premium upon constant innovation. Supermarkets adopt the bright colors of a Charles Moore or Ricardo Legoretta project, hiding their corporate uniformity behind deceptive exteriors. Industrial detailing transforms even the neighborhood Chinese eatery into a hilarious parody of Ove Arup engineering.

Writing a lexicon of contemporary Los Angeles architecture would entail compiling an inventory of the strategies—programmatic and tectonic—to facilitate the experience of forced reconciliation with a built environment desperately seeking to deny its location and to disavow estrangement from its actual surroundings. Walter Benjamin's famous suggestion that architecture is best experienced in a state of distraction might be reformulated to the effect that in Los Angeles distraction is best conveyed by the presence of architecture.[1] Yet here distraction is not Benjamin's school for cognitive insight, as it is Marcuse's repressive desublimation, the social manipulation of ludic and libidinal energies, which attains a new level of architectural sophistication in Southern California where pop culture and digital technology have eclipsed the formative potentialities of space.[2]

It would be difficult to imagine an architecture more distant from this nightmare of the (techno)culture industry than Lorcan O'Herlihy's, whose buildings studiously avoid the question to which most of Los Angeles culture ultimately responds: Are we having fun yet? In their unobtrusive presence, his houses and even his commercial structures evoke Martin Heidegger's understanding of inhabited place as one where we can feel at home and discover space through the experience of dwelling.[3] The spatiality facilitated

A folding storage wall of light birch plywood at the Harriet Dorn Women's Clothing Store contrasts with the detail of the window shelves and stainless steel hanging rods (top).

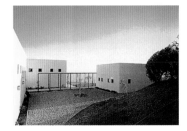

by O'Herlihy's architecture displays no elegiac or speculative gestures. It emulates neither the pathos of the high modernist villa nor the dematerialized frenzy of cyberspace. O'Herlihy's commissions are recognizable contributions to the architecture of daily life—residences, residential renovations and extensions, offices, and retail spaces that manage to circumvent the tired intellectual agendas and typologies frequently associated with such constructions. They respond to the imperatives of the urban environment in Los Angeles with a deft sensitivity and a stubborn commitment to formulating an architectural language adequate to the present.

The house O'Herlihy built for his parents in 1987 on a nine-acre (four-hectare) site perched high above Zuma Beach in Malibu already suggests the consistently fresh reworking of traditional forms that would become a signature trait of his architecture. A cursory look leaves the impression of a white stucco-clad cube—evocative of the plaster-finished vernacular buildings the architect came to know in Ireland—framed by a swimming pool edged with bricks and tile on one side and a vine-covered pergola on the other. A little later one notices, for example, the irregular spacing of large doors and much smaller windows, and the manner in which their deployment draws attention to the length of a wall. Eschewing perfect symmetry, the placing of these apertures in imperfect proportion to each other hints at O'Herlihy's emphasis upon designing lived space, at his predilection for the real rather than abstract geometries. (His is a modernism without Platonism; the particular determines the ideal.) The ten-foot- (one-meter-) square windows, thirteen-foot (four-meter) ceilings, and seventeen-foot (five-meter) elevations of the house make it larger and less dainty in appearance than the typical residences designed by Neutra or Adolf Loos, while exposed wood-beam ceilings and glazed-tile floors give the interiors warmth and suggest continuity with the surrounding trees and mountains.

View of the entry courtyard at the O'Herlihy Residence (top). The Freund-Koopman Residence entry (opposite) with the office above the garage utilizes translucent channel glass.

At the Freund-Koopman Residence in Pacific Palisades, O'Herlihy was able to work on a scale larger than that of most residential expansions, and it is only after visiting the house (which is peculiarly recalcitrant to photography) that one realizes just how gracefully its considerable mass fits on a sloping corner lot without dominating the other houses on the street. Immediately recognizable as an instance of local vernacular residential architecture, the original green wooden dwelling with overhanging eaves is an elevated version of the bungalows one encounters while driving around Los Angeles but never thinks about twice. O'Herlihy boldly transformed it into the center pavilion of the expanded house and flanked it with two pavilions characterized by elongated white surfaces, shimmering glass, sinuous curves, and a bowed step railing. Commentators have compared the elevated deck and bedroom pavilion to a ship—a response to the palpable dynamism of the building—yet the nautical comparison only partially describes the ambitions of the Freund-Koopman house. With its juxtaposition of varied surfaces, its proliferation of entrances, and its play of spaces, elevations, styles, observation points, volumes, and materials, the expanded dwelling points beyond a mere sea vessel to the complexity of a city.

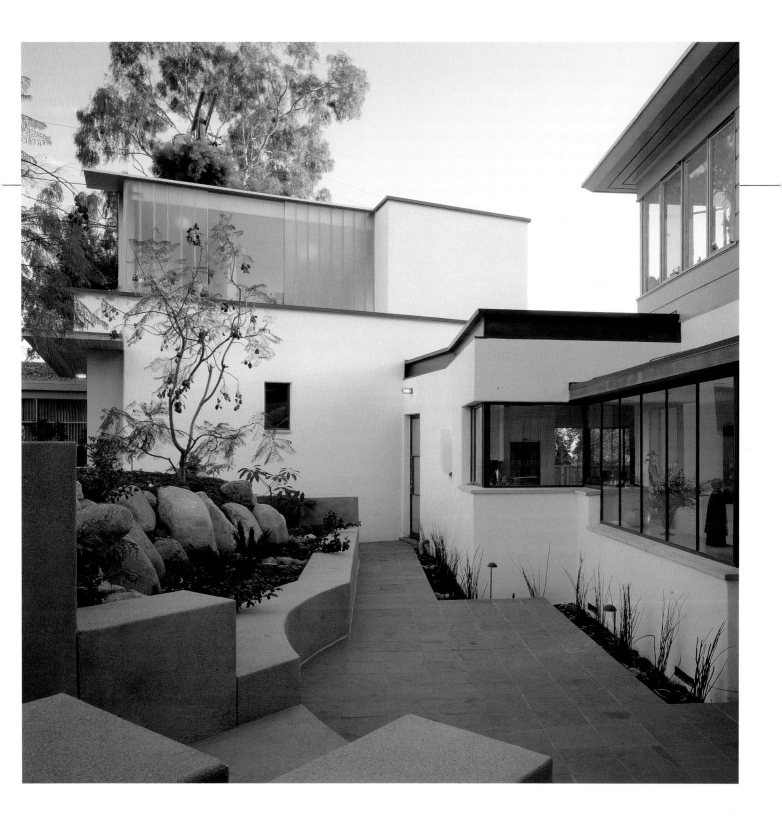

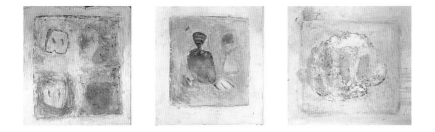

The house elicits perceptions more frequently encountered in a vibrant metropolis than in residential architecture. This is most evident in the treatment of the deck, a veritable private urban piazza of space bounded by old and new buildings and panoramic views of the surrounding neighborhood. It welds Freund-Koopman together—and here is one secret of O'Herlihy's architecture— with an uncommon sense of openness. Minor touches such as a glass tile skylight visible from the bedroom below create visual excitement on the deck. Unlocked at the center, this open core not only inspires a full appreciation of the house's elements but also connects it to the city, inviting us to experience it as a place in the widest sense.

The intimacy of the Freund-Koopman residence's deck and interiors is complemented by an equally potent "metropolitanism." Evident in the stunning steel-framed windows and skylights that punctuate the living areas with light, it is perhaps most conspicuous in the cantilevered canopy that meets the glass walls of the study pavilion, a minor detail from which the architect has wrested poetry. Coolly translucent and held in exquisite visual equilibrium by the shadows of the wraparound window below, this section conveys O'Herlihy's remarkable skill at constructing dynamic space from the alternation of transparency and volume, the agility with which his buildings oscillate between being visible and providing vantage points of the metropolis. The German-fabricated U-glass walls dramatically connote the vertical city, rendering the back of the house as two office towers pressing tightly upon a city plaza. These intersecting translucent surfaces insure privacy and suggest an architectural equivalent of the stimulus shield described by Georg Simmel as the indispensable psychic armor of metropolitan life.[4] Like the urbanite whose vacant facial expression protects a fragile interiority, the glass walls screen out external stimuli from the street and reveal building technology in the act of facilitating dwelling.

Paintings by Lorcan O'Herlihy (top) reflect the balance between continual control and spontaneous gesture. The Dowling bathroom (opposite) with cast glass bowl and birch cabinetry.

Set in Malibu, the Kline Residence displays this dynamism of O'Herlihy's architecture to even greater effect. Constructed as a series of vertically deployed volumes, rectangular boxes and a graceful, cylindrical pavilion cascading down a hillside, it presses the dematerialization of surface even further, in this case creating an exciting counterpoint between the flowing surfaces of the glass walls and a framework of reinforced concrete-and-wood detailing. Illuminated at night, the upper deck bursts with energy and light, its open space practically a streetfront of glass facades enlivened by the architect's dazzlingly varied treatment of fenestration. I cannot view this exterior without thinking of the dramatically lit nocturnal boulevards of Paris, inviting as they do pedestrian activity and the contemplation of incandescent urban space, a perceptual richness generally absent from residential buildings. O'Herlihy has occasionally referred to his architecture as panoptical, a phrase that captures the pleasure in looking evoked by many of his buildings, but neglects the dynamism of the mobile observer that his architecture presupposes. Three types of glass (clear, sandblasted, and translucent) modulate visibility and the flow of light, a significant dimension of the Kline residence's appeal. Nowhere is this more apparent than in the living room, whose corner of glass walls framed by crimson steel beams provides dazzling views of the ocean.

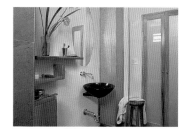

From within, high ceilings create a striking living room traversed by colored joists and complemented by brightly painted walls and an invitingly wide wooden stairway. They recall the architect's paintings and their application of thick patches of bright color to the canvas. As in his visual art, O'Herlihy's buildings actively explore surface and texture. They exude a warmer feeling than many designed today in a modernist style, a consequence in part, I believe, of his predilection for wood-appointed interiors, a design feature evident in his residential and commercial projects and conspicuous in many of his smaller-scale projects as well. Vertically mounted birch cabinets punctuate the walls of the bathroom in his Dowling Renovation, their rich grain accentuated by the green slate tiling on the floor and in the shower stall. Floating off the wall and the ceiling, the sink and the shower head introduce dynamism and volume into the program of a tiny room measuring only six and a half by ten feet (two by three meters). Wood assumes a more prominent role still in the Harriet Dorn Clothing Store, located in Frank Gehry's Edgemar Development in Santa Monica. A hinged, folding wall of light birch plywood built by cabinet maker Steve Shelley is the background against which hanging plywood and metal clothing racks take on the look of three-dimensional sculptures. The racks free up the limited two hundred square feet (twenty square meters) of trapezoidally shaped space, and the wall fills the room with a luscious texture. Displaying his propensity for exploring the play of light and mass, the architect floated a white nylon parachute from the ceiling fifty-two feet (sixteen meters) high to soften the natural illumination entering from a skylight. Crossed by the steel rods that support the clothing racks, the billowing parachute heeds the store's vertical plan (not to mention the forces of gravity) and is an inventive exploitation of the space's height and an urban verticality seldom found in the ground-clinging precincts of small-scale retail architecture in Los Angeles. By echoing the graceful suspension of dresses on the hanging clothing racks, the parachute invites us to ponder the close relation between fashion and building, while reminding us that the seduction both arts stage depends upon a precise attention to detail—a crease of fabric draping the shoulder, the play of light upon the texture of wood.

O'Herlihy's Los Angeles architecture affirms its location in the city (an occurrence more rare than one might suppose) with a joyful sense of connection to its urban surroundings. One of my favorite instances of this is his Delicatessen R&B on Santa Monica's Main Street, a shopping district littered with architectural mediocrity that I had long considered beyond redemption. Clad in shiny white tiles, the delicatessen appears from a distance too good to be true: its clear lines and absence of ornamentation make one hold one's breath in anticipation of some glitch of corporate standardization. But coming nearer one finds that nothing whatsoever about the building is standardized and that all of its features, from the asymmetrical facade and display window to the varied lettering of its signage, have been designed with great care, as if offering a tacit indictment of the increasingly formulaic world around it and us. No recent commercial building that I know of counters the blandness of contemporary retail architecture with greater freshness.

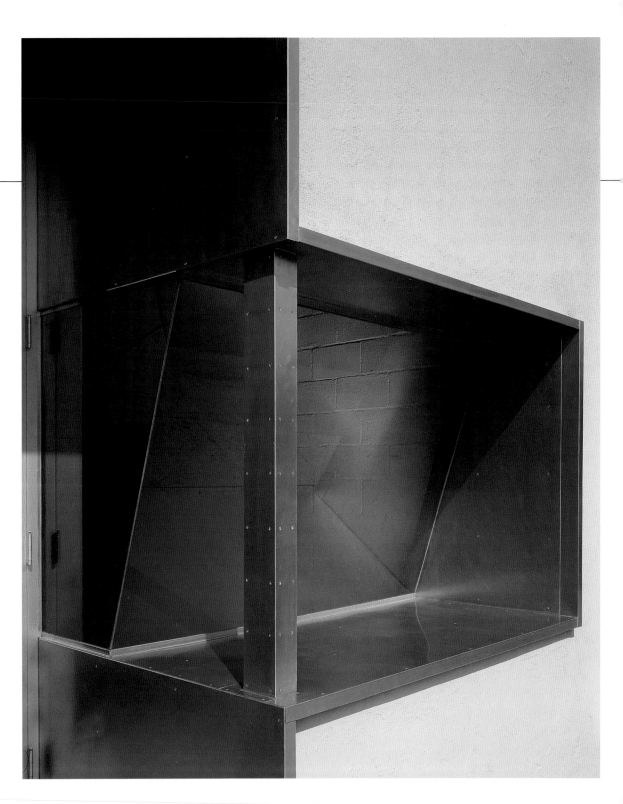

Folded glass and aluminum façade of the Julie Rico Gallery (right). Plan and façade of the Delicatessen R&B (opposite) showing how the white ceramic tile on the exterior is carried inside, accented by a mosaic floor overlaid with a mondrian-inspired black grid and squares of primary colors.

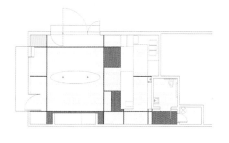

Built with simplicity and lack of pretension, the delicatessen proposes itself as a new mode of vernacular retail architecture, unabashedly generous in its conviction that even consuming a sandwich and a bag of potato chips should transpire in an environment of quiet beauty. Trees cast their shadows upon the smooth and glowing tiled facade that is extended above the height of the store's interior. Stepping inside, one encounters an inviting orderliness. Wooden door-jambs, shelving, cabinetry, and chairs encourage customers to linger and soak up the ambience of the sunny room, a space whose warmth makes so much of contemporary retail design seem impossibly contrived and slick by comparison.

A sloping glass panel to the left of the entrance extends the elevated tile floor beyond the edge of the display window. On the right side, the tile floor functions as a front step, blurring the boundary between interior and exterior space and recalling the façade with its similarly recessed doorwell and diagonally sloping glass wall that O'Herlihy designed for the Julie Rico Gallery. A small side porch and a pivoting glass panel lead out to the motel court next door, linking the delicatessen to its immediate environment with conspicuous ease. Architecture does battle here with the stereotypes of popular culture and emerges victorious without being sanctimonious. Not a building for dwelling in the sense understood by Heidegger, the delicatessen reveals instead the space of everyday being with other people (das Man, "the they") that the philosopher posited as a fundamental category of modern urban life.[5] When peering at Main Street through this window, we are separated from the city yet conscious of our shared identity with its inhabitants. O'Herlihy constructs a realm for an urban solitude all too uncommon in Los Angeles.

All Los Angeles architects require some theory (explicit or implicit) of the relation of their efforts to the entertainment industry, the greatest purveyor of images and spaces both locally and globally. O'Herlihy does not reject cinema, only its superficial appropriation as a substitute for thinking. Filmic images and references are not incorporated in his work as so many undigested bits of cultural plankton but rather approached as modes of spatial perception and storytelling. "How the architect works with a shape, form, light, balance, color, movement and expression within the geography of space and depth is how architecture manifests itself," he writes.[6] At both the Architectural Association and the Southern California Institute of Architecture, he has taught a studio course on cinema and architecture in which students view films as an inspiration for the design process and as an introduction to varied experiences of spatial passage and narration.

A similar impetus is evident in his design for a house on the Isle of Man, in which the architect provides "a cinematic ramp," an elaborate device of cadrage (framing) that simultaneously reveals and conceals views of the ocean, foregrounding both the temporality of movement, on and off screen. Surrounding an open courtyard, the sunken center of the house, the ramp leads to an observation deck and an studio/editing room for the film industry client who commissioned the project. Here the segmentation

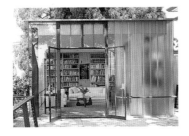
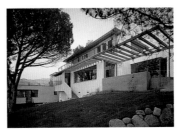

of his earlier houses is directed centripetally inward, dividing the plan into a series of rooms that coil their way into a seashell-like spiral. Glass, colored plaster, stone, and pilotis are its construction materials, and the overall effect combines the elevated drama of California canyon dwellings with the grounded masonry architecture of Great Britain—the world and the earth (in Heidegger's terminology) joined together.[7]

Juxtaposing spectacular views of Scotland and Ireland with a place for the production of images, the Isle of Man residence proposes an architecture that balances nature and culture, rationalism and sensuality, America and Europe, technology and dwelling through the exercise of a lucid and tactile intelligence. Whether he continues to work in California or returns to Europe to build projects such as the Isle of Man commission, O'Herlihy will undoubtedly retain his enthusiasm for the modernist idiom and his tenacious insistence upon constructing with space rather than slogans.

Built atop an apartment complex in Marina Del Rey, O'Herlihy's most recent residential project, the Kelly Penthouse, demonstrates his continued interest in generating an orderly plan from detached pavilions set within a grid. Here the rooftop site dictates a horizontal unfolding of elongated rooms on two levels. As in his other houses, the architect has designed a structure of maximum openness whose interiors and exteriors compose a unified, flowing whole, frankly Miesian in approach and fully at ease with a free plan whose lack of boundaries might well frighten many designers. Organized as a continuous plane running from the oceanfront balcony to the back terrace, the interior of the space is again softened by wood, in this case maple floors and cabinetry.

The library of the Freund-Koopman Residence consists of one wall of books with a central window and three walls of clear and translucent glass that flood the space with light. View towards master bedroom wing "hovering" above the hillside. Detached office pavilion at the Kelly Residence (opposite) is located on the open rooftop terrace and continues the idea of detached pavilions set into the grid.

The element of the Kelly Penthouse that immediately draws one's attention and elicits the most revealing comparisons with the Freund-Koopman and the Kline residences is the detached office pavilion located on the open rooftop terrace. Exterior space and spectacular views of the surrounding city become elements of the plan of the house, as O'Herlihy once more finds a way to puncture the enclosed envelope of the building's space. In contrast to the Freund-Koopman residence, here one must walk outside the main living area to reach the office, which is connected to the main building only by a metal- and-wooden trellis. The office pavilion is truly a citadel from which it is possible to see without being seen—O'Herlihy's most exact realization of panoptical space yet. As if resisting the pressure to supply one more view of the beach, the delicate cube faces toward Los Angeles and thus away from the ocean realm, a suggestive linkage of visual mastery with the forces of civilization and renunciation. Pleasure and labor, the antinomies of Southern Californian life, find architectural expression in the Kelly Penthouse office pavilion, a projection booth from which the aporia of urban subjectivity unroll to the soundtrack of the surf and the flickering houselights of the metropolis.

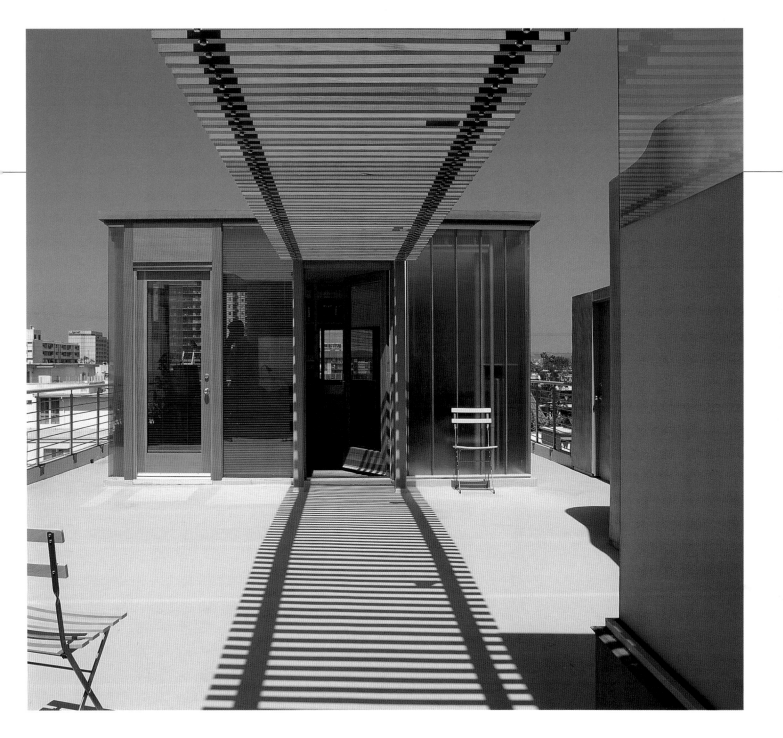

1. Walter Benjamin, "The work of Art in the Age of Mechanical Reproduction," in *Illuminations*, ed. Hannah Arendt, trans. Harry Zohn (New York: Schocken Books, 1969), 239–40. **2.** See Herbert Marcuse, *Eros and Civilization: A Philosophical Inquiry into Freud* (New York: Vintage Books, n.d.), 71–95. **3.** Martin Heidegger, "Building, Dwelling, Thinking," in *Poetry, Language, Thought*, trans. Albert Hofstadter (New York: Harper Colophon Books, 1975), 145–161. **4.** Georg Simmel, "The Metropolis and Mental Life" trans. H. H. Gerth with C. Wright Mills, in *The Sociology of Georg Simmel*, ed. and trans. Kurt Wolff (New York: Free Press, 1950), 409–424. **5.** Martin Heidegger, *Being and Time*, trans. Joan Stambaugh (Albany: SUNY Press, 1996), 119. **6.** Lorcan O'Herlihy, "Architecture and Film," in *Architecture and Film* (London: Academy Editions, 1994), 91. **7.** Martin Heidegger, "The Origin of the work of Art," in *Poetry, Language, and Thought*, 17–87.

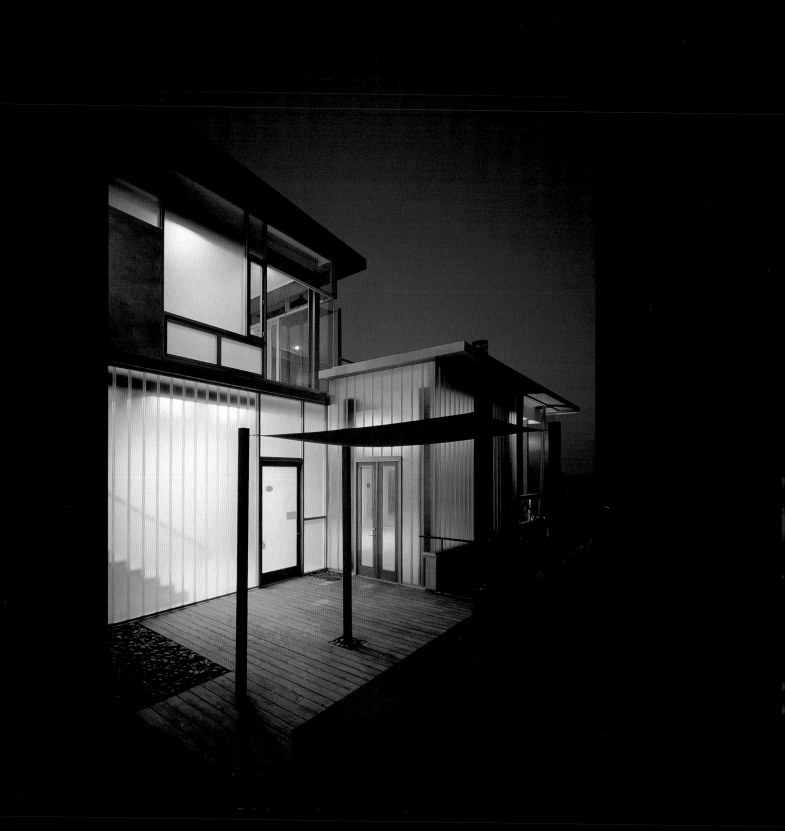

Residential Works ▶

Kelly Residence

MARINA DEL REY, CALIFORNIA

The Kelly residence is a renovation of a 1,800-square-foot (167 square-meter) beachfront penthouse in Marina Del Rey for a young couple. The design concentrated on stripping the existing shell back and opening up the space to create a loft environment. It was critical to take advantage of its wonderful location by opening it up to light and reinforcing its panoptic ocean views. A new 130-square-foot (12-square-meter) library was also added on the roof terrace.

An emphasis was placed on maintaining the shell as a simple canvas in which a limited number of vignettes could be played to solve both programmatic concerns and also reinforce spatial relationships within the project. A distinctive palette of materials and details was chosen to provide architectural coherence to these interventions and overall clarity to the project.

Specific relationships relating the project to the site (earth to sky, land to sea, the predominance of the horizon line) played an important role in the design. The long, narrow proportions of the loft and the axial perspectives created are reinforced by the catwalk that extends from the bedroom loft over the living area and through the curtain wall on the ocean side, terminating in a perch from which to survey the beach and view the sunset. A trellis leading from the loft to the library on the roof terrace continues this axis. In the vertical axis, maple floors and ceiling emphasize the role played by the diaphragm of the project, reinforced by the stair that floats before a wall of translucent channel glass and makes the transition between floors highly visible.

Real advantage was taken of the space's location within the building, a penthouse with one exterior wall. This allowed for light to be used as an architectural material. Skylights are carved at the intersection of wall and ceiling, thus breaking the box and making one aware of the project's relationship with the sky. A light-well cut out over the stair showers it with light while a wall of translucent glass announces it on the lower level; an opaque glass corner in the shower fills the room with light while maintaining privacy.

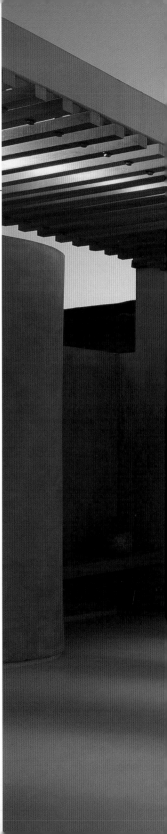

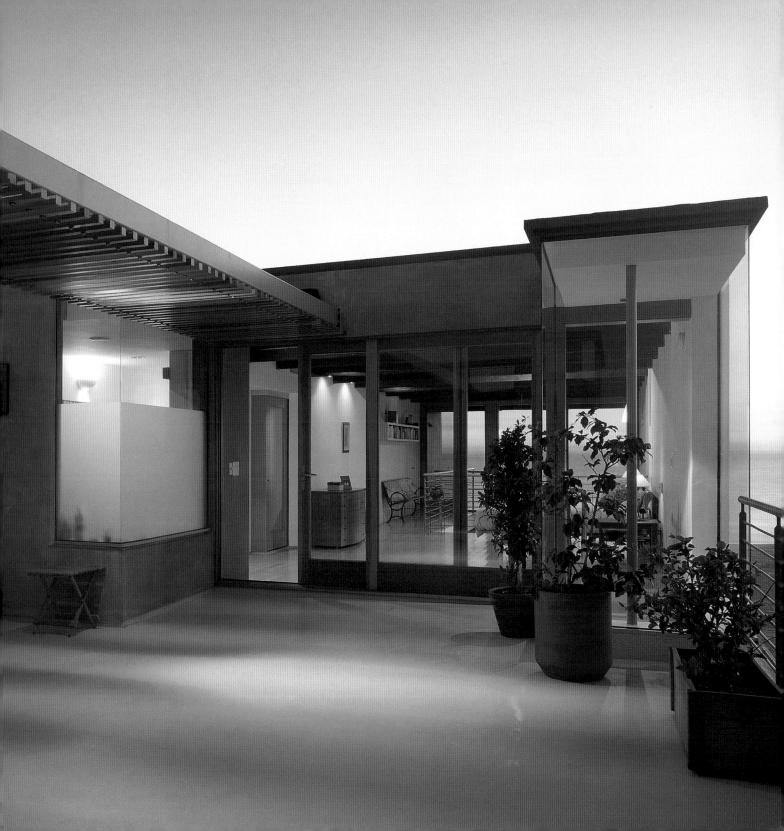

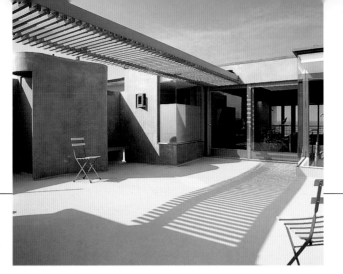

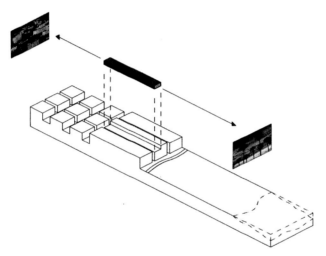

Top to bottom: The master bedroom frames the "outdoor" room; conceptual drawing showing axis of proposed design; detached office pavilion located on the open rooftop terrace. During the day, the sun floods the office with natural light through translucent and clear glass. Preliminary perspectival studies, floor plans and section indicating programmatic elements in a free plan that is visually continuous (opposite).

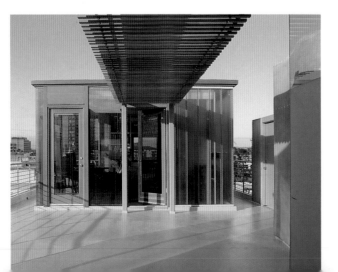

KITCHEN/DINING ROOM PERSPECTIVE

LIVING ROOM PERSPECTIVE

KITCHEN/DINING ROOM PERSPECTIVE

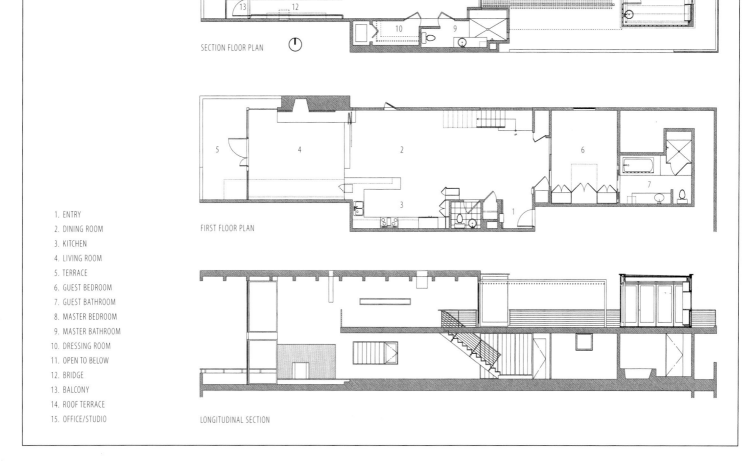

SECTION FLOOR PLAN

FIRST FLOOR PLAN

LONGITUDINAL SECTION

1. ENTRY
2. DINING ROOM
3. KITCHEN
4. LIVING ROOM
5. TERRACE
6. GUEST BEDROOM
7. GUEST BATHROOM
8. MASTER BEDROOM
9. MASTER BATHROOM
10. DRESSING ROOM
11. OPEN TO BELOW
12. BRIDGE
13. BALCONY
14. ROOF TERRACE
15. OFFICE/STUDIO

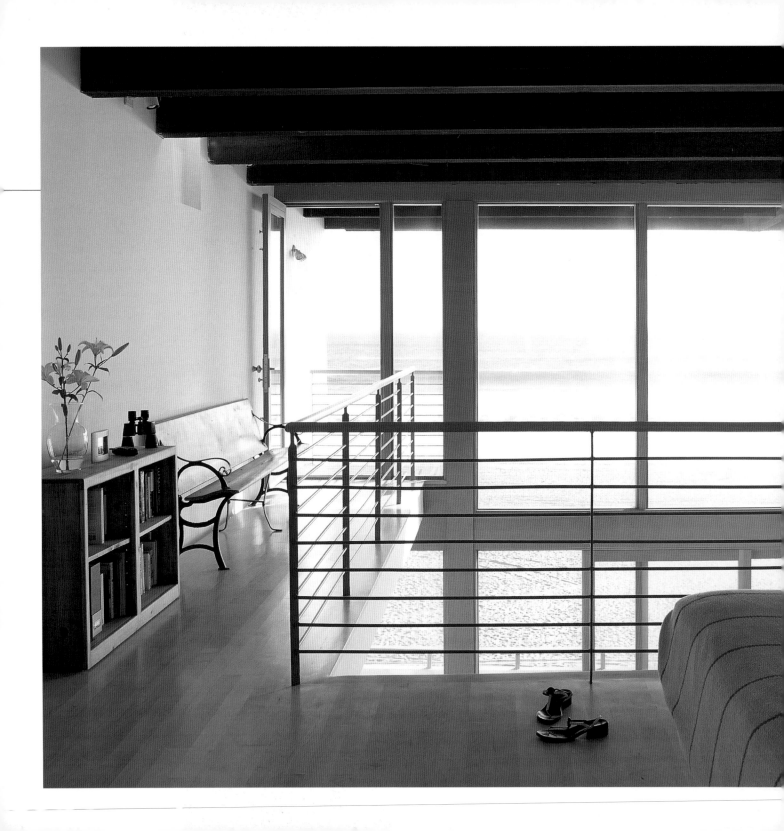

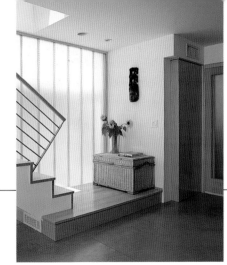

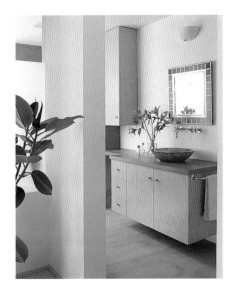

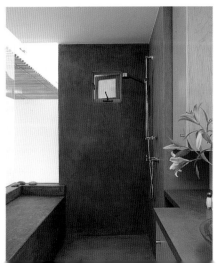

View towards Pacific Ocean from
master bedroom (opposite). Channel
glass floods light into stairwell; the
master bathroom with cast glass sink
set into floating cabinet and view
of open shower in master bathroom
(top to bottom).

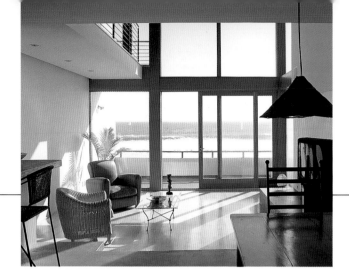

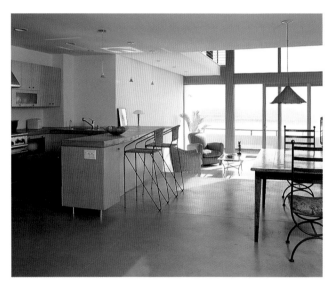

The double-height living room peers out to the Pacific Ocean and catwalk above extends from the bedroom loft through the curtain wall to a perch from which to view the sunset. The relationship of kitchen to living and dining rooms is mediated by a concrete countertop (top to bottom). Preliminary perspectival study and construction photographs (opposite).

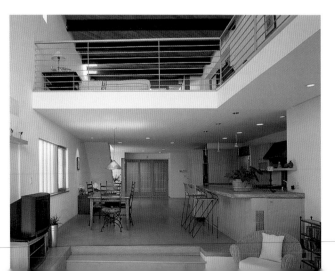

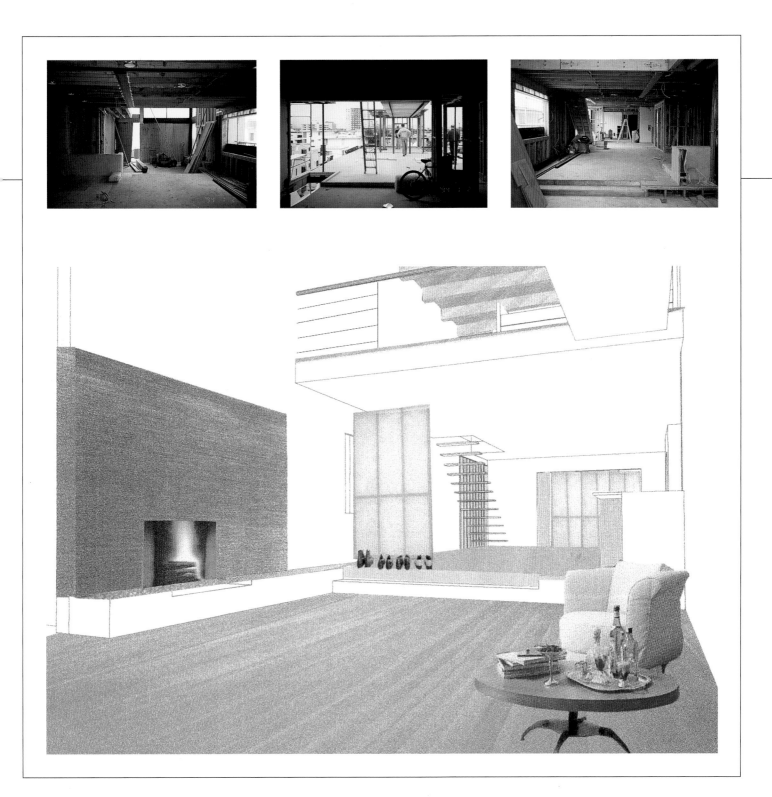

Beckstrand/Goldhammer Residence

PALOS VERDES, CALIFORNIA

Located on a hill overlooking the Pacific Ocean, the Beckstrand/Goldhammer Residence features an overwhelming panoramic view. The steel skeleton, prefabricated in Los Angeles and transported twenty-five miles (forty kilometers), allowed for a rationalist building.

The original cost of the residence was $12,000. The patio on the east is sheltered from ocean winds and is connected with the living room. The elegant Beckstrand residence (1940) seems bigger than it is because of its siting—in the midst of an orange grove overlooking the coast of the Palos Verdes peninsula. The renovation of the house was to respect the original concepts by removing walls, adding new materials and colors, and simplifying flooring materials.

The house was oriented both toward the wonderful panoptic views and a part of the site that was originally landscaped. Unfortunately a number of speculative houses have recently being built in the area the house used to look out upon. O'Herlihy reoriented the kitchen and dining area away from these speculative houses and toward the ocean views as well. The renovation included all wall, floor, ceiling, window, and door surfaces, as well as new window coverings. New birch cabinetry was designed for the living room, as well as birch paneling in the dining room.

The furniture chosen was a combination of early modernists such as Le Corbusier as well as more contemporary pieces, such as a Frank Gehry chair and simple coffee tables from Shelter. The glassware was bought from OK showroom.

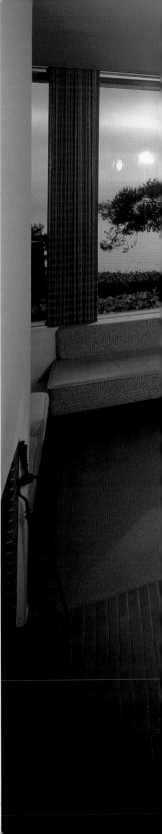

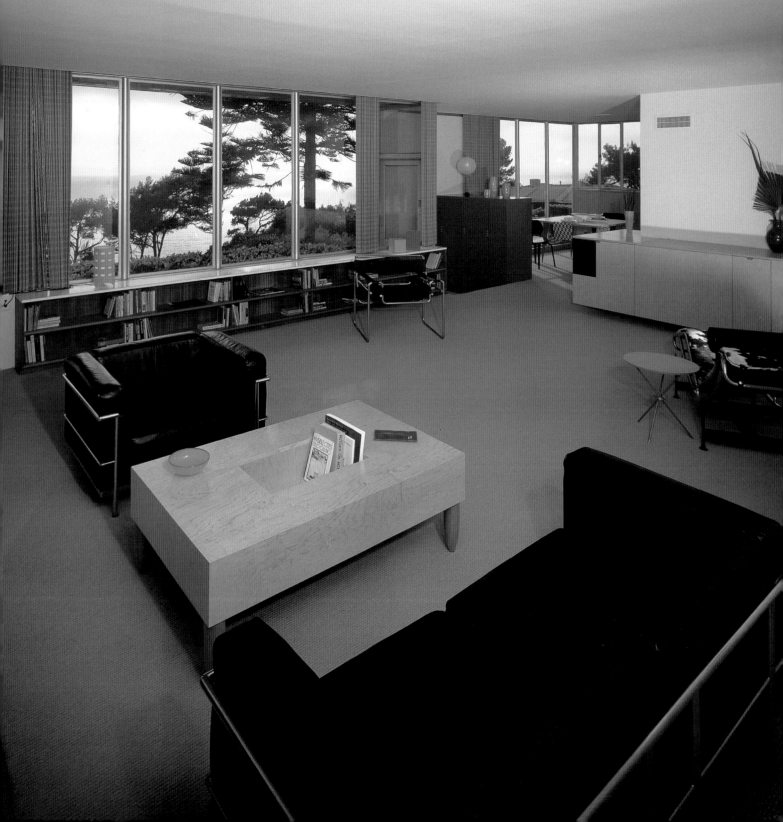

Rather than restoring the house as a museum of its former self, O'Herlihy intervened subtly, reframing spaces and fittings so as to produce an entirely contemporary, yet true modernist dwelling (top to bottom). Shown is the kitchen entry, panoptic view of the Pacific Ocean, and plans indicating location of program elements (opposite).

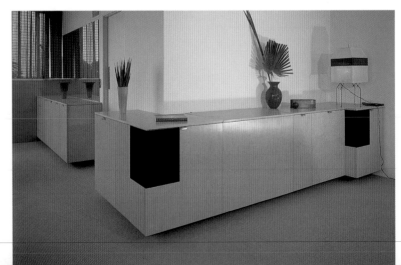

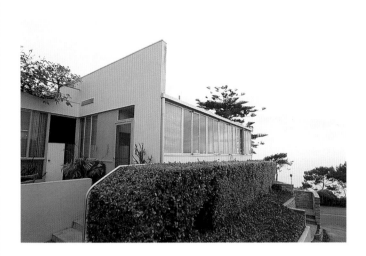

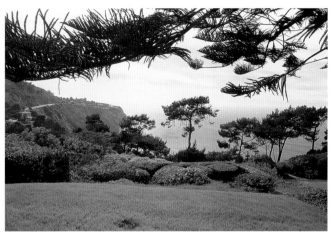

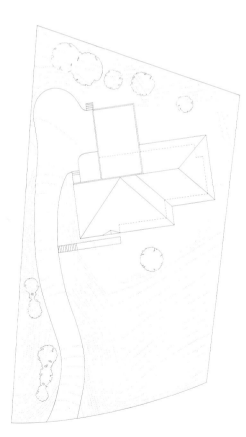

1. ENTRY
2. LIVING ROOM
3. DINING ROOM
4. KITCHEN
5. BEDROOM
6. STUDIO/OFFICE
7. MASTER BEDROOM
8. DRESSING ROOM
9. BACK TERRACE
10. GARAGE

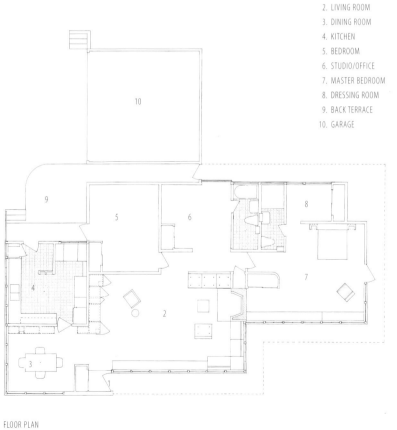

SITE PLAN

FLOOR PLAN

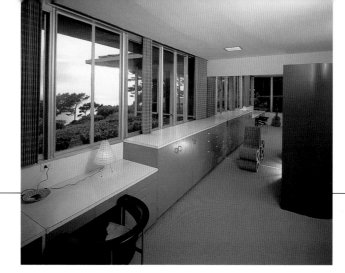

Conceptual sketch shows the restoration of bedroom area which included refinishing existing cabinetry and a color scheme that respected both Californian light and Neutra's original vision. Later the bedroom is supplemented with a Frank Gehry chair.

Speedway Residence

VENICE, CALIFORNIA

A narrow lot in a row of similar lots parallel to the Pacific Ocean is the site for the project. A view of the ocean is possible at the north and east edges. Light and materiality are taken as the architectural expression. Due to the wonderful quality of the light from the Pacific Ocean, the house becomes dematerialized to allow for a architecture of translucency. The interior courtyard becomes a key focus as the house opens up to this exterior space. As you move upward, the house shifts to a light construction in which the skin of the envelope hangs from a moment frame construction. The main stair floats in the main space. The decks at the second level face both the interior courtyard as well as the Pacific Ocean.

Construction is of stained concrete block and U-Glass on the ground level. The interlocking forms at the second and third level are constructed out of brass panel with a red acid patina (blue, yellow, and black). The glass is made of clear and translucent U-Glass, sandblasted glass, and resin panels. The decks at the second and third level are two-foot (sixty-one-centimeter) square concrete pavers.

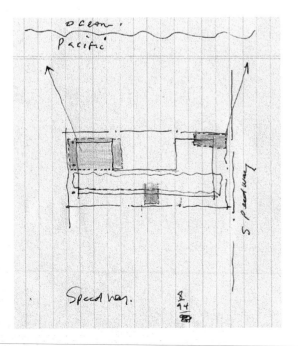

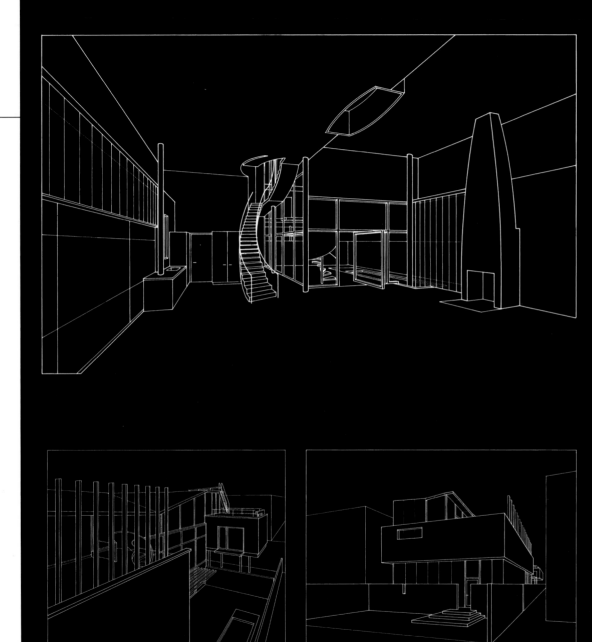

Perspectival studies reflect the vertical dematerializing of the structure. The skin of the envelope at the second floor hangs from a moment-frame. The U-shaped plan of the residence reflects a site-specific response to the narrow lot and limited views. The desire to frame an outdoor courtyard became critical (opposite).

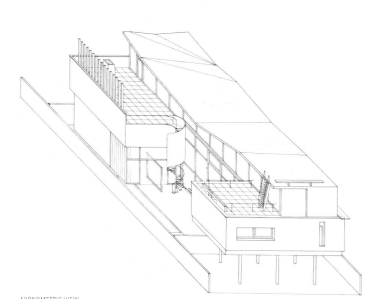

AXONOMETRIC VIEW

NORTH ELEVATION

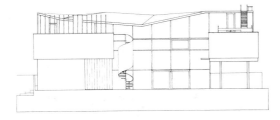

SOUTH ELEVATION

SITE PLAN

1. ENTRY
2. LIVING ROOM
3. DINING ROOM
4. KITCHEN
5. PANTRY
6. BATHROOM
7. CARPORT
8. COURTYARD
9. REFLECTING POOL
10. DECK
11. MASTER BEDROOM
12. MASTER BATHROOM
13. DRESSING ROOM
14. STUDIO
15. BEDROOM

FIRST FLOOR PLAN

SECOND FLOOR PLAN

Singledge Residence

The site for this project is a nineteenth-century industrial building on a plain in Coldred, Kent County, England. The Guildford Coal Mining Engine House is a 3,200-square-foot (300-square-meter) masonry building, some eighty feet (twenty-four meters) tall, with three-foot-(one-meter-) thick walls. The building, on the National Register of Historic Places, was purchased by a couple as a retirement home that would provide rooms where their adult children could stay during visits.

Proposed was a "house within a house," to build a glowing glass jewel-box within the monumental shell of the engine building. This provided a unique opportunity to build a project of light construction in this climate, while it also pleased local planning officials because of its minimal impact on this important building's exterior. Of interest to us was that the project would contain the element of surprise; the exterior shell acted as a "mask" for the interior.

The interior of the house contrasts the exterior shell in scale (intimate vs. monumental), material (steel and glass vs. masonry), and form (free-floating, flat-roofed pavilion vs. grounded and pitched A-frame shed). The interior house slips in and around the existing engine mounts. The client's spaces are located on the ground floor, with their children's spaces above. The residual spaces between the interior house and the shell are to be developed as an interior garden, an "outside-inside space."

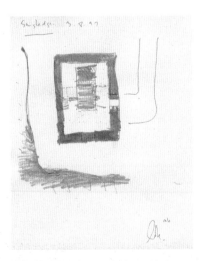

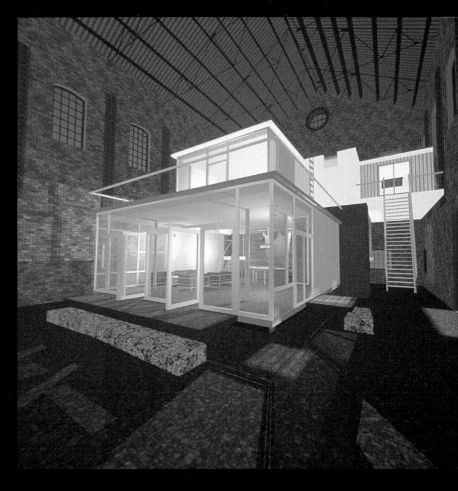
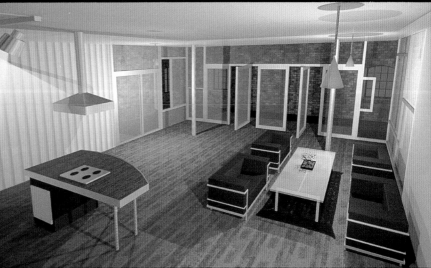

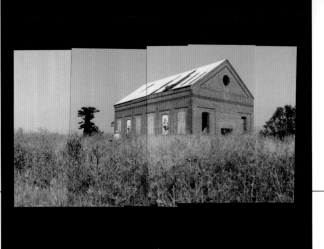

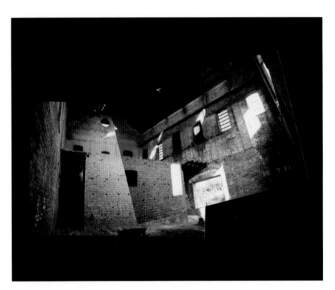

Photographs of existing Coal Mining
Engine House, and plans reflecting
the disposition of programmatic
elements. Axonometric diagrams show
the house-within-a-house concept
and outside-inside space (opposite).

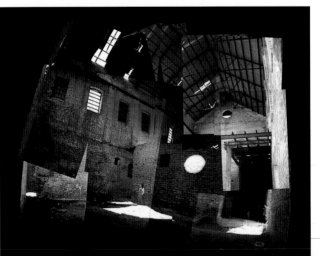

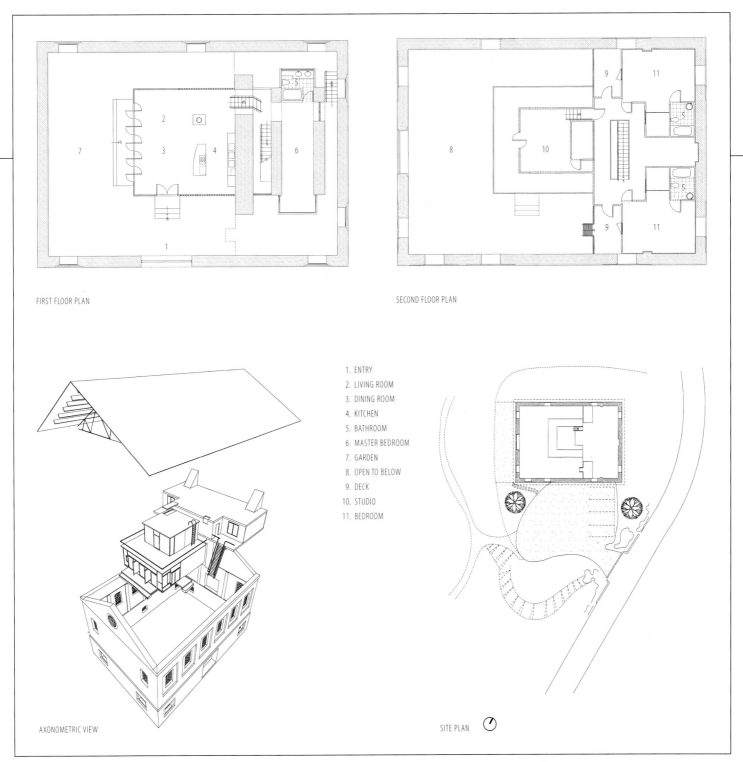

FIRST FLOOR PLAN

SECOND FLOOR PLAN

1. ENTRY
2. LIVING ROOM
3. DINING ROOM
4. KITCHEN
5. BATHROOM
6. MASTER BEDROOM
7. GARDEN
8. OPEN TO BELOW
9. DECK
10. STUDIO
11. BEDROOM

AXONOMETRIC VIEW

SITE PLAN

Meaney Addition

This project is an eight-hundred-square-foot (seventy-five-square-meter) master bedroom addition to the Studio City home of an actor. The client insisted only that the exterior of the addition be sympathetic to the typology of the existing house and that the interior accommodate his eclectic taste in furnishings (a combination of Irish antiques and modern classics).

The A-frame of the existing roof was extended to the end of the addition. In order to open the house up to the pool and leave room for circulation, the corner of the room was carved away beneath the roof where the four pivot doors were installed, breaking the pure A-frame geometry.

In order to leave the interior as open as possible, closets were replaced with built-in cabinets, integrating the bed and side tables. This element also works to zone the room. The bed, oriented toward the pool, creates a sitting area and changing area to either side. The cabinetry wraps back to a corner door that opens into the master bath. In the bath, the use of transparent glass for the shower and freestanding pedestal sinks give the illusion of a larger space.

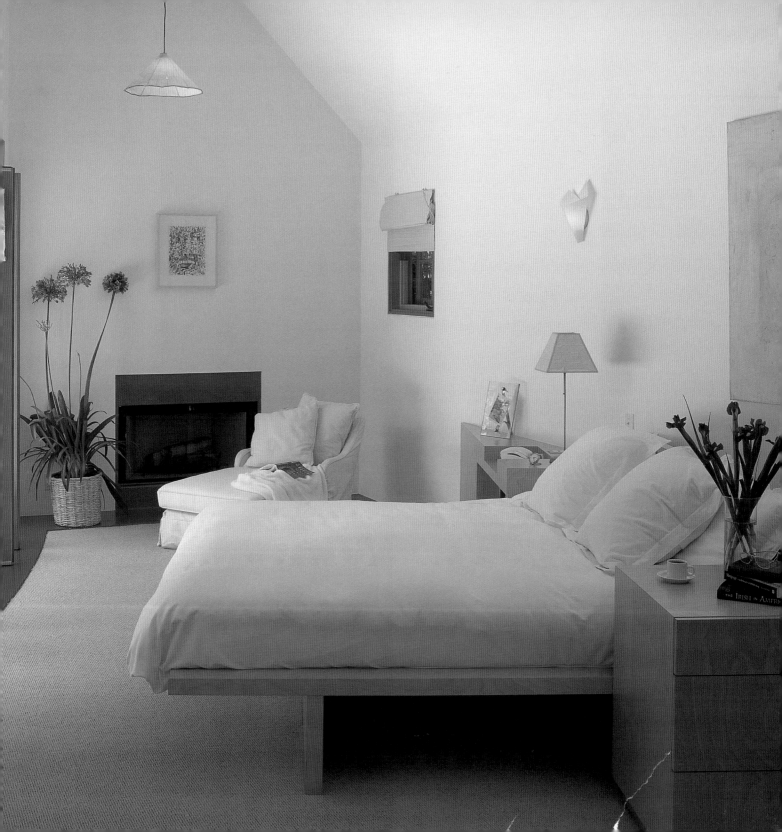

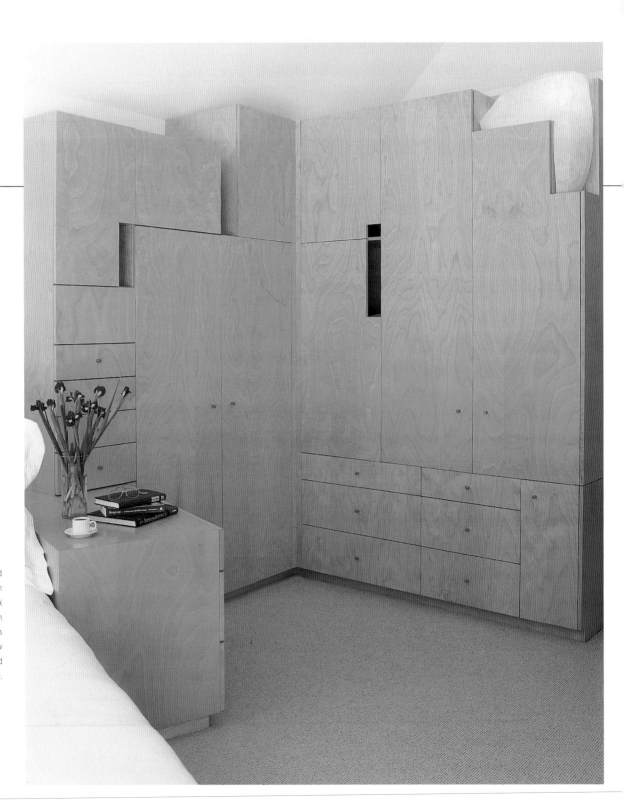

Floor-to-ceiling closets are crafted from birch. Pivot glass doors open along elliptical curve framing back yard; slate-tiled bathroom with above-counter sinks on birch stands (opposite). Site plan and plan show programmatic elements and connection to existing house.

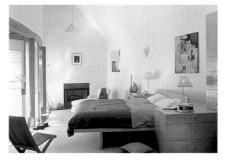
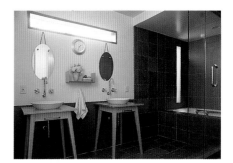

1. MASTER BEDROOM
2. MASTER BATH
3. EXISTING HOUSE
4. MECHANICAL

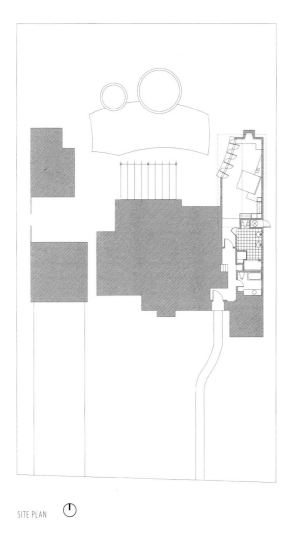
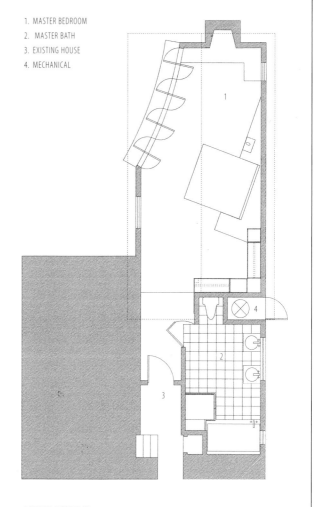

SITE PLAN

ADDITION FLOOR PLAN

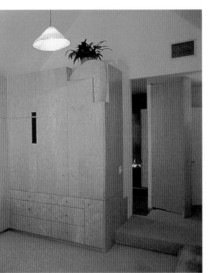

CROSS SECTION

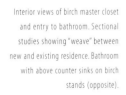

Interior views of birch master closet and entry to bathroom. Sectional studies showing "weave" between new and existing residence. Bathroom with above counter sinks on birch stands (opposite).

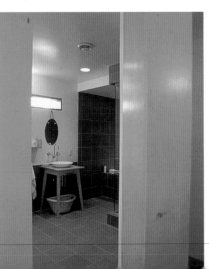

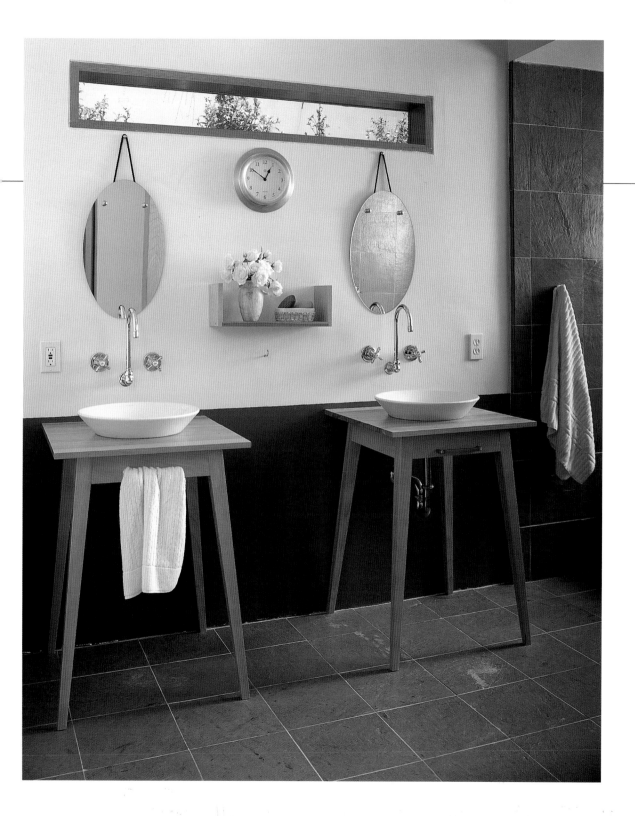

Goldhammer Residence

The Goldhammer Residence is situated on a 50- by 124-foot (15- by 38-meter) infill lot located in a quiet residential area of Manhattan Beach. With houses to either side enclosing the site, views from the lot are quite restricted. The owner's program called for a 3,400-square-foot (316-square-meter) house for a single man, which built upon Southern California's tradition of indoor/outdoor living.

Due to the restricted nature of the site and its lack of views, the solution turns to a typology especially well-suited for Southern California's pleasant weather and its inhabitants' desire for outdoor living, the open courtyard house. Offering an alternative to the trend of shoehorning three-story houses into narrow sites, an "outdoor room" (courtyard) was created, in which space and light are taken as the material of the architectural expression. The front yard, rear yard, and side yards become the "outdoor room" around which the house wraps in a series of interlocking solids and voids defining spaces in plan and section, with indoor spaces flowing to the outdoors.

The house is more solid toward the street, blocking the noise and providing a "screen" for privacy. The house progressively opens up as one enters into the interior world of the courtyard. Indoor spaces flow from one to another, from inside to out, through a number of spatial and atmospheric filters varying in transparency and density of construction. The master bedroom is located above the living room with a hinged wall that can be opened to the living room or closed for privacy. The living and dining rooms are open-plan; they flow into each other as well as into the outdoor room.

The house is wood-frame construction with integral color plaster finish along its perimeter and a steel moment-frame with a glass curtain wall along the threshold between the courtyard and the living/dining and kitchen spaces. The glass curtain-wall is both transparent and translucent depending on the need for privacy.

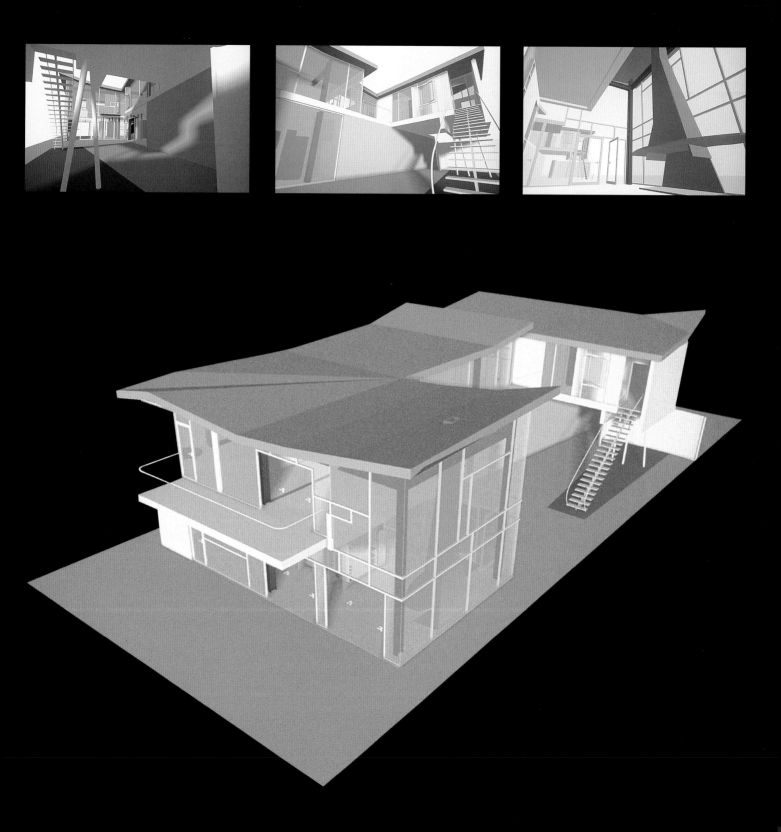

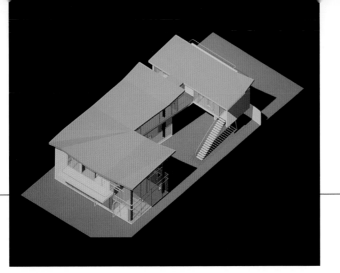

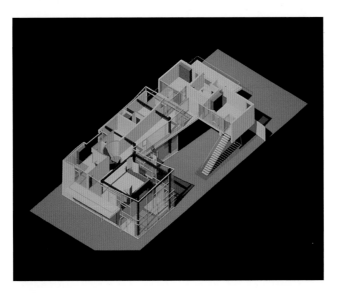

Due to the restricted nature of the site, axonometric studies were used to study the open courtyard house, which is well suited for southern California's weather and outdoor living. Plan and sectional studies (opposite).

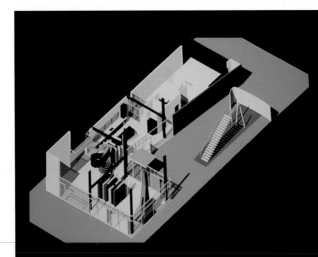

SECTION THROUGH LIVING ROOM

SECTION THROUGH CORRIDOR

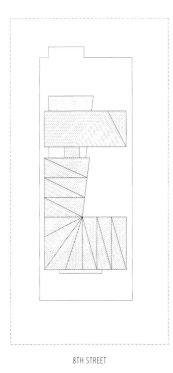

8TH STREET

SITE PLAN

1. ENTRY
2. LIVING ROOM
3. DINING ROOM
4. KITCHEN
5. GARAGE
6. COURTYARD
7. OPEN TO BELOW
8. MASTER BEDROOM
9. MASTER BATHROOM
10. SAUNA
11. DRESSING ROOM
12. STUDIO
13. BRIDGE
14. BEDROOM
15. BATHROOM
16. DECK

FIRST FLOOR PLAN

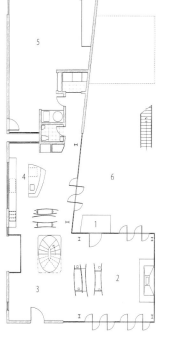

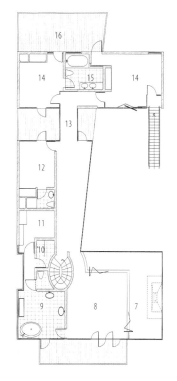

SECOND FLOOR PLAN

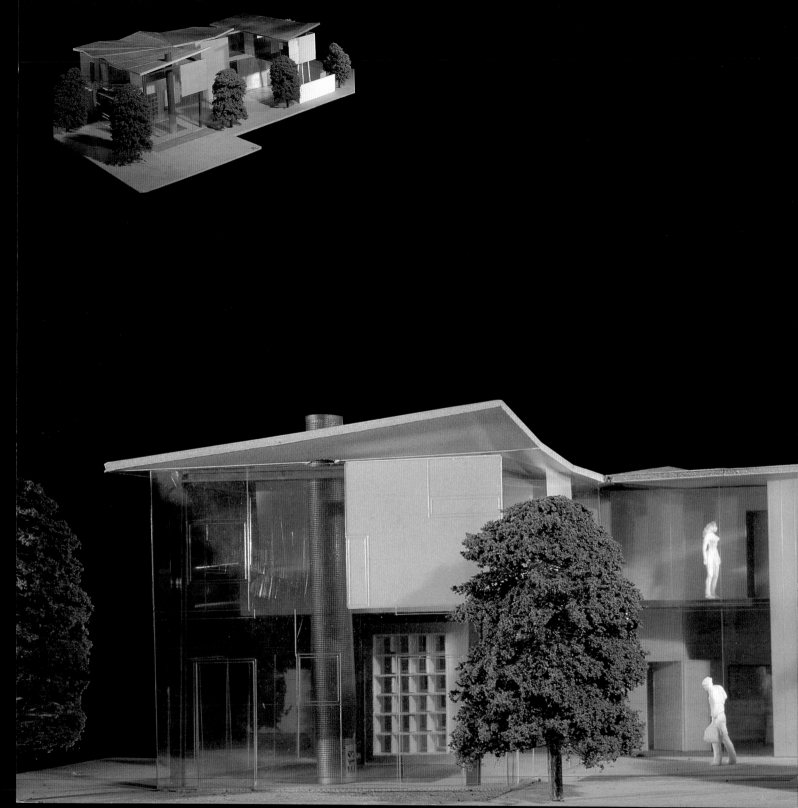

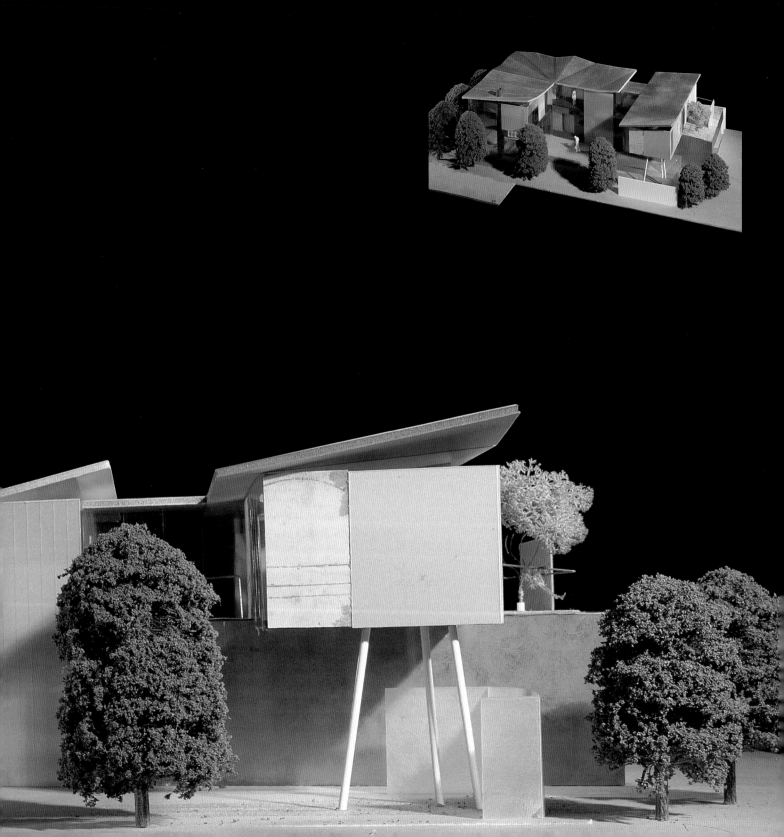

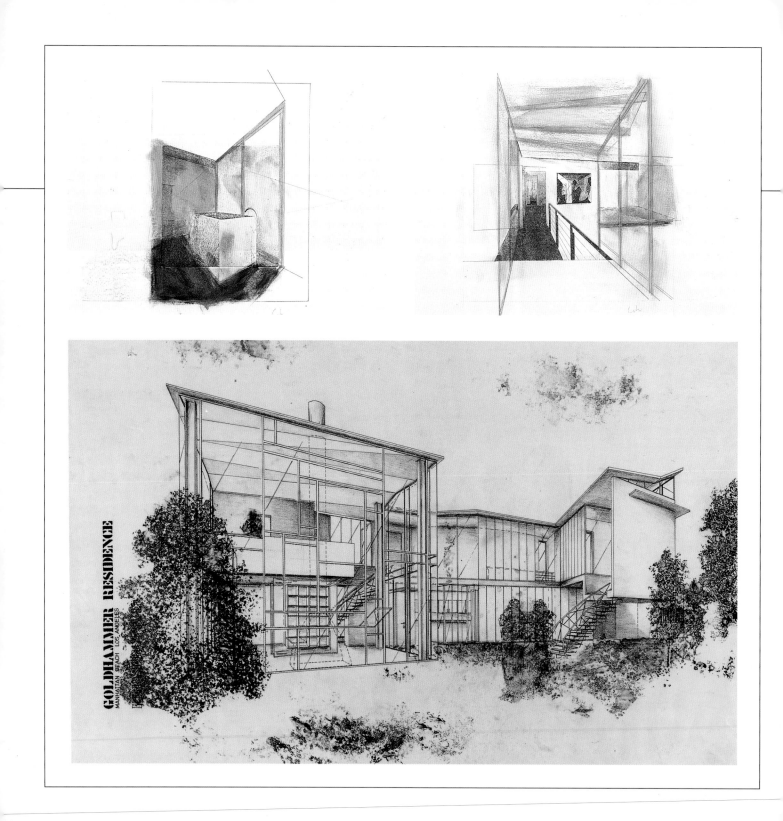

GOLDHAMMER RESIDENCE
MANHATTAN BEACH LOS ANGELES

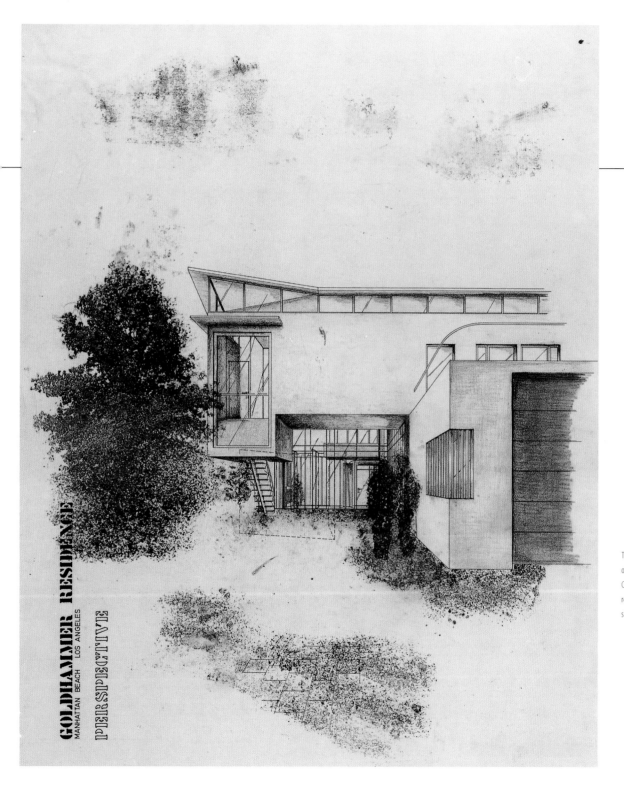

GOLDHAMMER RESIDENCE
MANHATTAN BEACH LOS ANGELES

PERSPECTIVE

The house screens off the street and
opens when entering interior courtyard.
Conceptual sketches show interior bath-
room and bridge; perspective study
shows dematerialized façade (opposite).

Isle of Man Residence

The site for the Isle Residence is a ten-acre (four-hectare) plot of land located on the northwest point of the Isle of Man (situated off the northwest coast of England) and featuring panoptic views of Ireland and Scotland. The request was to design a house for a couple with specific requirements to address the wonderful 360-degree views of both the Irish sea and the land. Also critical to the project was the request to design an interior courtyard that would provide an area to relax outside without being confronted with the 100-mile-per-hour (160-kilometer-per-hour) winds prevalent on the island. The solution was to "wrap" the house around this "outdoor room." In order to take advantage of the extraordinary views, the house sets up a series of mise-en-scéne (as opposed to creating obvious relationship with the ocean vistas) linked by a "cinematic ramp" on which one passes through the house. To emphasize the continuous folding of the house onto itself, the interior ramp becomes a important piece of the architecture. As one moves through the house the program of spaces become disparate "scenes" not dissimilar to filmic narration. The house both blocks and exposes the framed views. By virtue of the framing possibilities of the editing process, the program is inverted (the kitchen is in the embryonic stage of the journey) to create an architecture that contains the element of surprise.

The client is a director and was interested in developing a space where he could project images of his work. The entry gallery became a "volume of images" consisting of these projected images on the translucent screens that can be seen as one approaches the house. As one passes through and participates in these projections one participates in the "event" of the architecture.

The construction is of concrete block with a veneer of stone and exterior smooth-troweled plaster at the point in which the house touches the ground. As the house "lifts off," the main structure becomes a steel moment-frame that "frees" the house from the ground and allows for an architectural expression of floating. Window opening frame specific views that are integrally tied to movement of a person in the house.

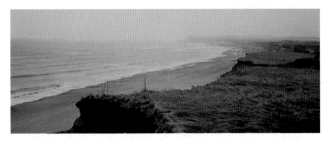

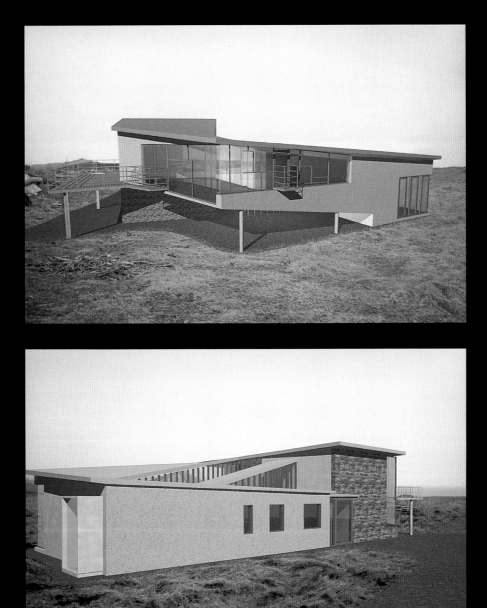

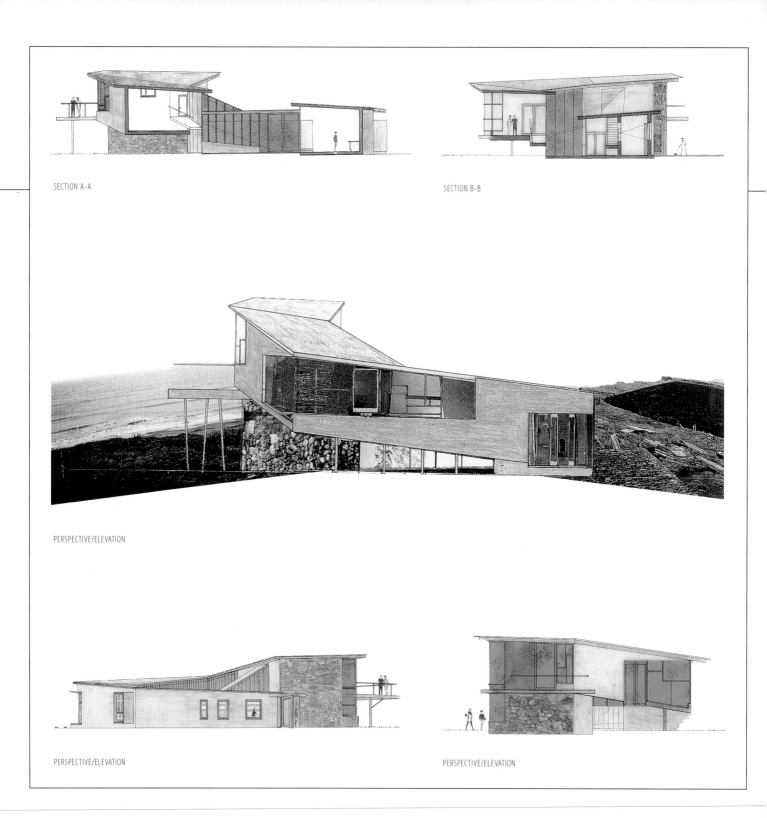

SECTION A-A

SECTION B-B

PERSPECTIVE/ELEVATION

PERSPECTIVE/ELEVATION

PERSPECTIVE/ELEVATION

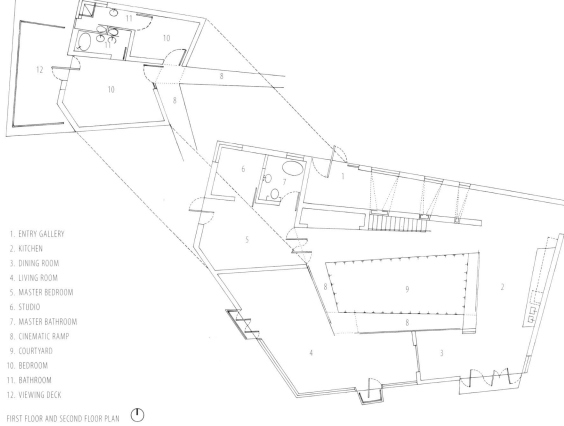

1. ENTRY GALLERY
2. KITCHEN
3. DINING ROOM
4. LIVING ROOM
5. MASTER BEDROOM
6. STUDIO
7. MASTER BATHROOM
8. CINEMATIC RAMP
9. COURTYARD
10. BEDROOM
11. BATHROOM
12. VIEWING DECK

FIRST FLOOR AND SECOND FLOOR PLAN

Photograph of site and plan show
programmatic elements and drawings
studying the folding of the house
around an interior courtyard.

Kline Residence

MALIBU, CALIFORNIA

The house sits on a narrow, steeply sloping lot, approximately 50 by 160 feet (15 by 50 meters) facing the Pacific Ocean. The deep vertical section of the site and its relation to the wonderful views suggested a site-specific strategy. The building's stereometric staggering of volumes was generated by the desire to trace the vertical section of the site.

Structure, volume, and light were taken as the root of the architectural solution, given the steep slope of the site and its relation to views. The house continues the slope in stereometric terms. Working with proportion and light, the living spaces break into a series of volumes that embrace a structural steel frame. Sectionally, the house is a layering of trays from the lowermost garage through reception zones to the master suite above, after which it breaks to allow for an elliptical pavilion, an independent unit for guests. The house is both shelter and outlook. The steel frame lifts the ocean-side end high in the air, surrounded by clear and translucent channel glass, and continues breaking down the constituent parts of the building. The interior life of the house is activated by extending itself to the exterior via the transparent but materialized walls.

The base construction is poured in-situ concrete shelving up the site, both vertically and in lateral shifts so that the pieces of the house lock into the land. The front part of the building is a steel moment frame that frees up the skin in order to allow for as much transparency as possible to take advantage of the ocean vistas. Translucent channel glass on the east and west façades provide light as well as visual privacy from the neighboring houses. Clear glass is in abundance toward the ocean views.

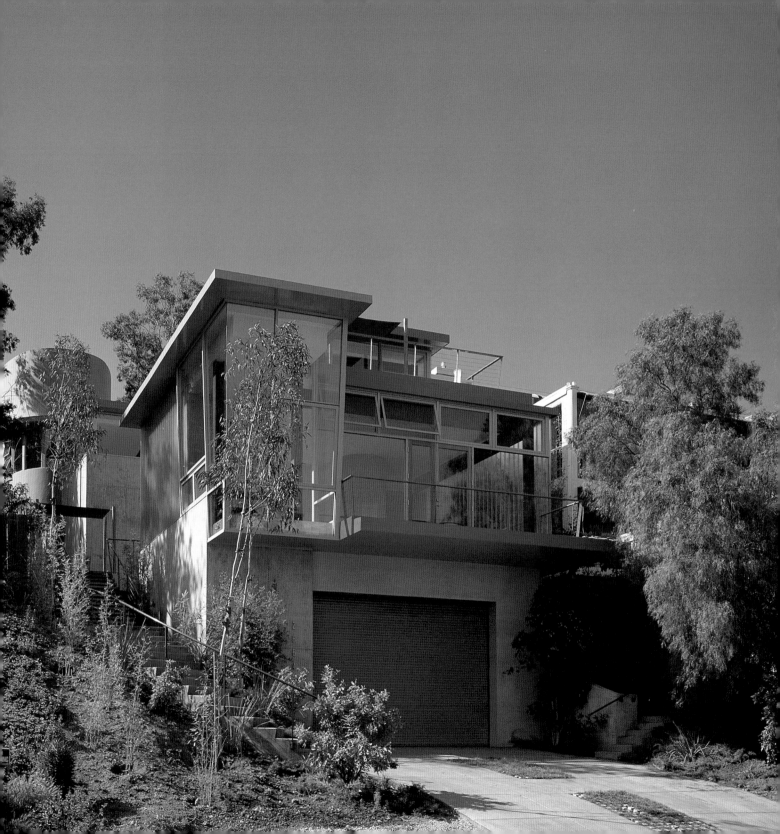

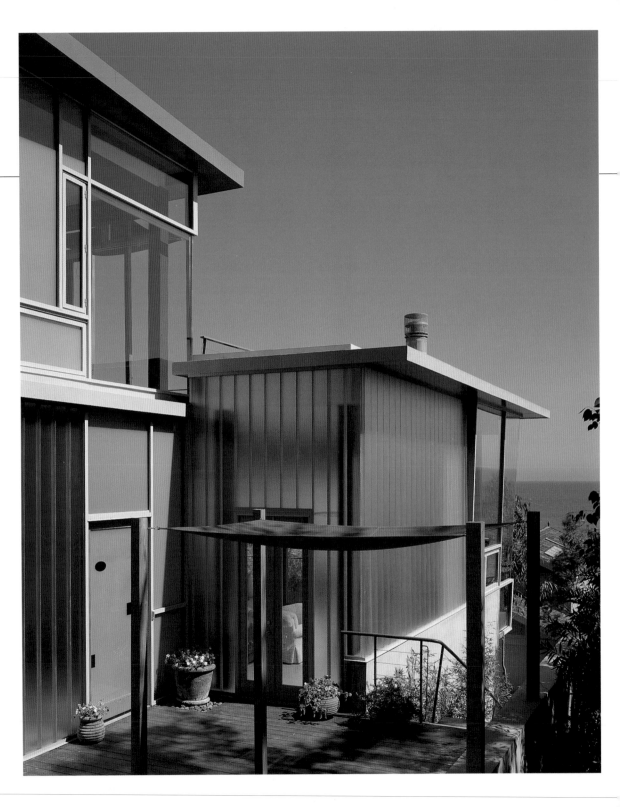

Kline Residence

Working with proportion and light, the
house breaks into a series of volumes
following the slope stereometrically,
facing views of the Pacific Ocean(right).
The setback of the steel moment frame
allows the doorway to "float" in a plane
of translucent channel glass surrounding
the entry court.

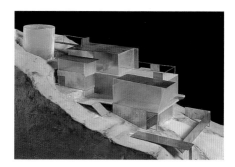

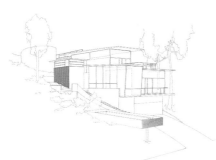

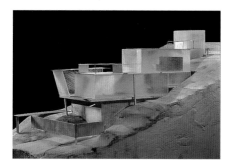

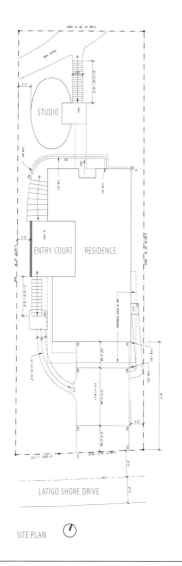

STUDIO

ENTRY COURT RESIDENCE

LATIGO SHORE DRIVE

SITE PLAN (1)

1. ENTRY COURT
2. ENTRY
3. LIVING ROOM
4. DINING ROOM
5. KITCHEN
6. PANTRY
7. POWDER ROOM
8. BEDROOM
9. BATHROOM
10. LOWER STUDIO
11. ROOF DECK
12. MASTER BEDROOM
13. MASTER BATHROOM
14. CLOSET
15. STUDIO
16. BRIDGE
17. UPPER STUDIO

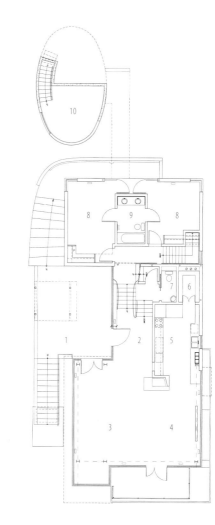

MAIN LEVEL PLAN

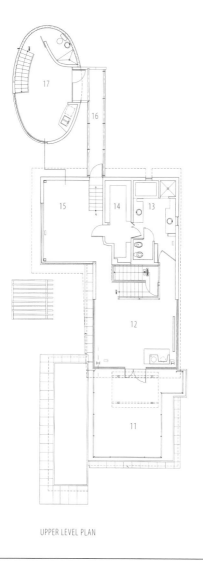

UPPER LEVEL PLAN

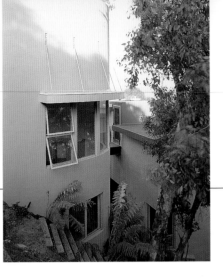

9
A10.4

FOR GUARDRAIL

3/16"

CONT. BLOCKING
JOIST HANGER
PLYWOOD
1 1/2" CONC. PAVER ON
PEDESTALS- ONE PANEL
FULL WIDTH
WATER PROOFING
3/16"

3'-0"

2 1/2"

JOISTS- SEE STRUCTURAL
DWGS.
PLYWOOD
STEEL BEAM- SEE
STRUCTURAL DWGS.
7/8" CONC. PLASTER OVER
PAPER BACKED MTL. LATH
3'-8"

SECTION AT BRIDGE

SCALE: 1"=1'-0" 2

An elliptical pavilion in the rear of
the house contrasts geometrically
with the main house and serves as
an independent unit for guests.
A bridge links the two structures.

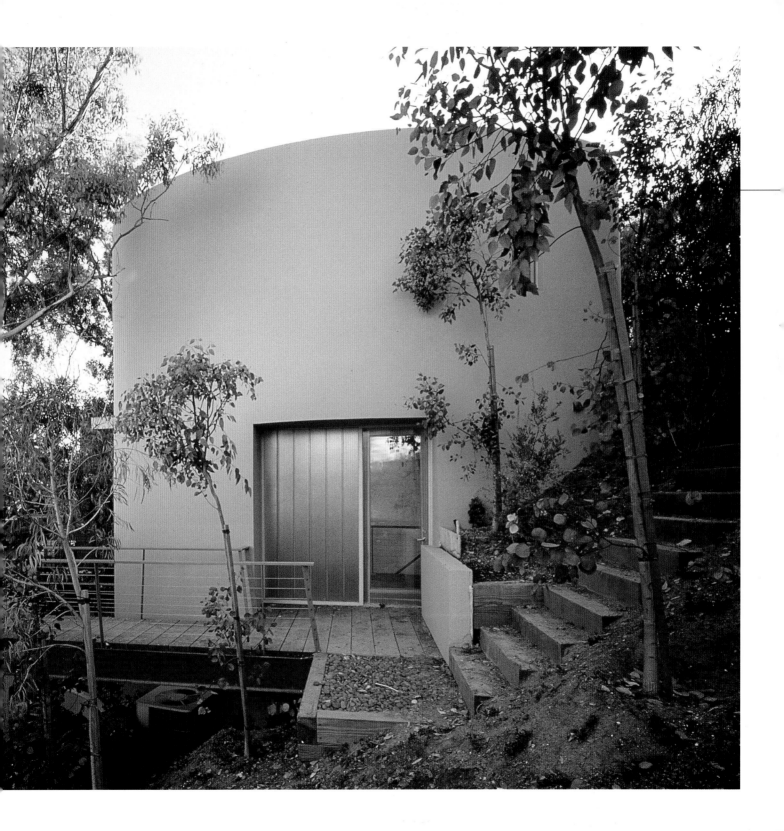

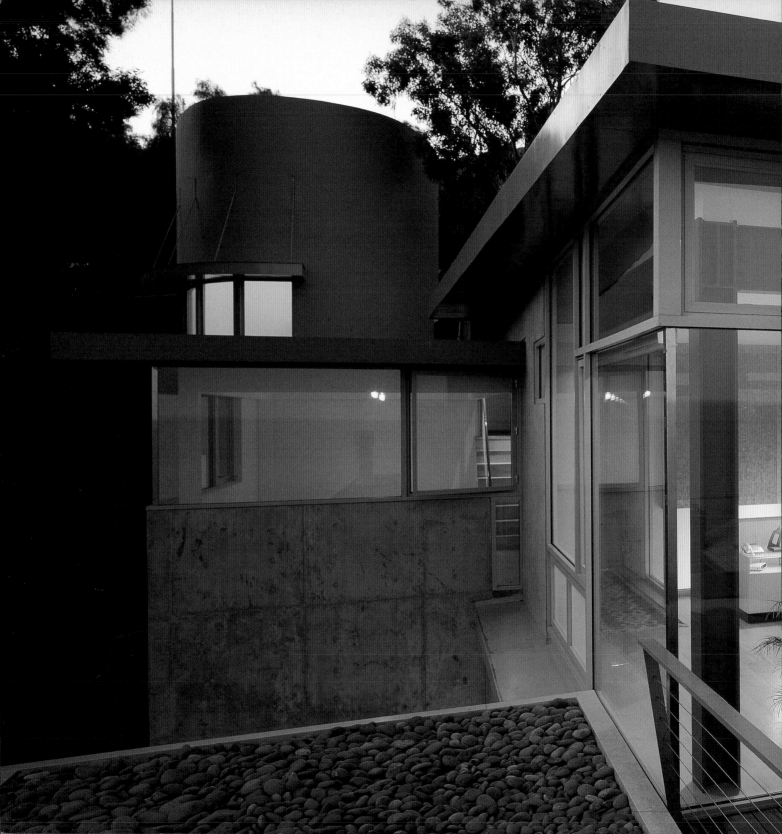

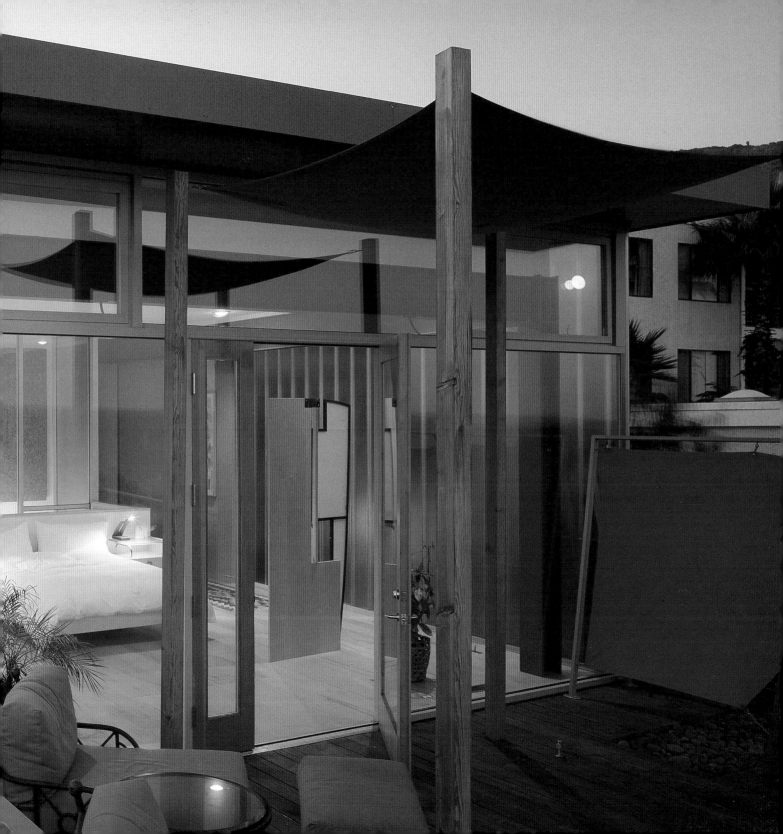

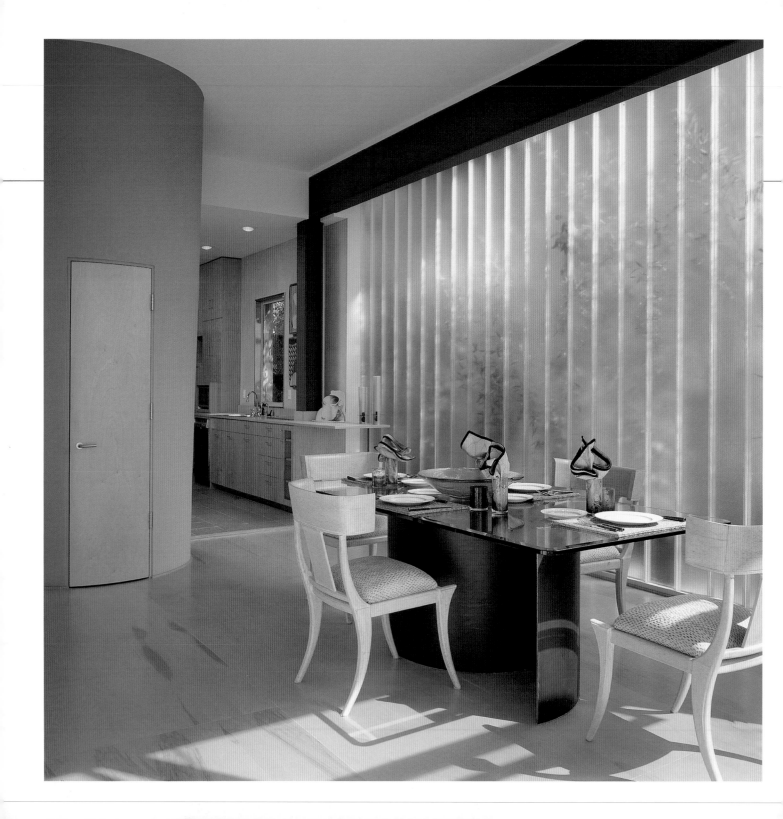

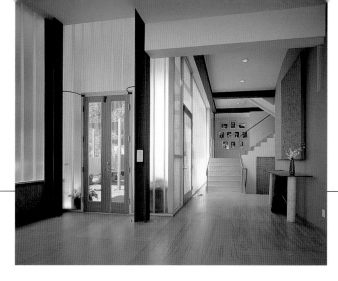

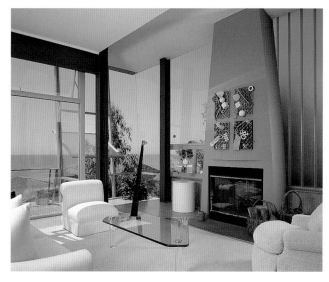

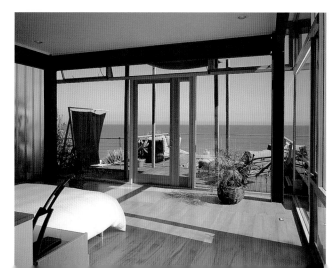

Structure, volume, and light were taken as the root of the architectural solution. View of entry, living room, and master bedroom (top to bottom). Translucent channel glass on the east and west façades provide light as well as visual privacy from the neighboring houses (opposite).

Freund-Koopman Residence

PACIFIC PALISADES, CALIFORNIA

The house sits on a sloping, irregularly shaped, ancient alluvial bluff in the Santa Monica Mountains. The double residential hillside lot is approximately 19,000 square feet (1,750 square meters), with southwest views toward the ocean and toward the Santa Monica mountains.

The Freund-Koopman Residence started as a 3,200-square-foot (300-square-meter) addition to a 1,400-square-foot (130-square-meter), wood-sided house in the Pacific Palisades. The commission grew in scope, requiring the demolition of all but the second floor of the existing house and eventually engulfing the original structure. At the outset of the project there was a study of hillside houses. The dominant approach offered a choice between "adhering" and "hovering" —between anchoring the building to the slope, or suspending the structure above it. It became clear that the solution was a combination of both. The main structure, given that it already "adhered" to the slope, remained so. Where new elements (such as windows) were added, a suggestion of suspension was accomplished by extending the overhangs and wrapping the windows around corners. The new bedroom/library addition hovers over the descending hillside, with its prismatic library volume on top completely enveloped beneath the broad canopy of existing pines. The new addition was supported by a recessed wall, thus adding to the illusion of hovering.

The residence attempts to create an ensemble of living volumes engaging the natural virtues of the site. The existing, inwards-looking house was oblivious to its beautiful wooded site; the intrigue of the project was going to be its

detailing and the differentiating between the diverse building components, including glass, steel windows, and cement stucco. This is apparent in the new master bedroom wing with its opaque lower-level suite and the glazed channel glass, recessed study above it.

The library is a good example of rethinking the idea of a wall: By using the channel glass and slipping the glass planes past the structural frame, the library takes on the illusion of lightness with a thin roof framing edge and a wall of glass.

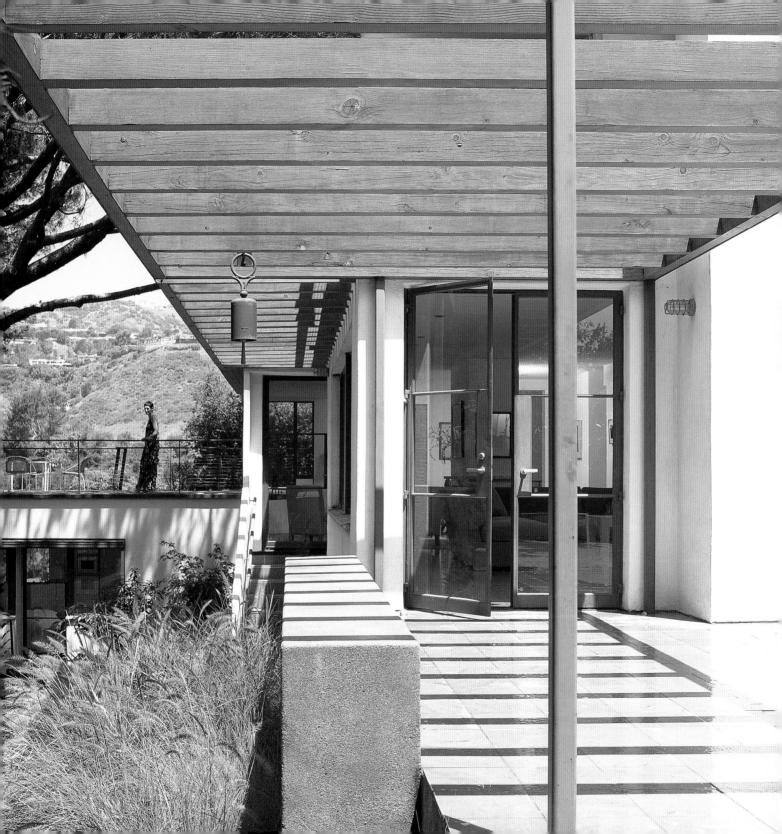

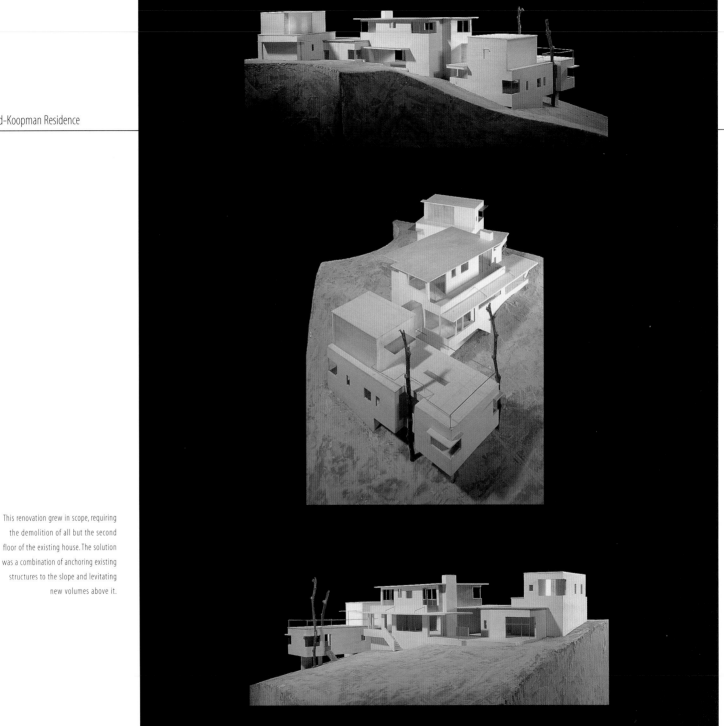

This renovation grew in scope, requiring the demolition of all but the second floor of the existing house. The solution was a combination of anchoring existing structures to the slope and levitating new volumes above it.

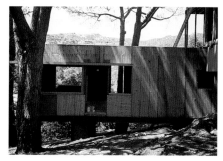

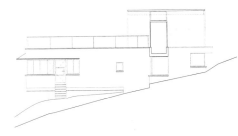

NORTHWEST ADDITION ELEVATION

SOUTHWEST ELEVATION

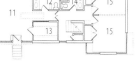

LOWER LEVEL PLAN

MAIN LEVEL PLAN

1. ENTRY
2. LIVING ROOM
3. DINING ROOM
4. KITCHEN
5. LAUNDRY ROOM
6. GARAGE
7. TERRACE
8. BRIDGE
9. CONSERVATORY/LIBRARY
10. DECK
11. MASTER BEDROOM
12. MASTER BATHROOM
13. DRESSING ROOM
14. BATHROOM
15. BEDROOM

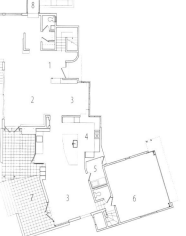

SITE PLAN

A. EXISTING RESIDENCE
B. ADDITIONS
C. GARAGE (BELOW)
D. DECK
E. POOL AND DECK (NOT BUILT)

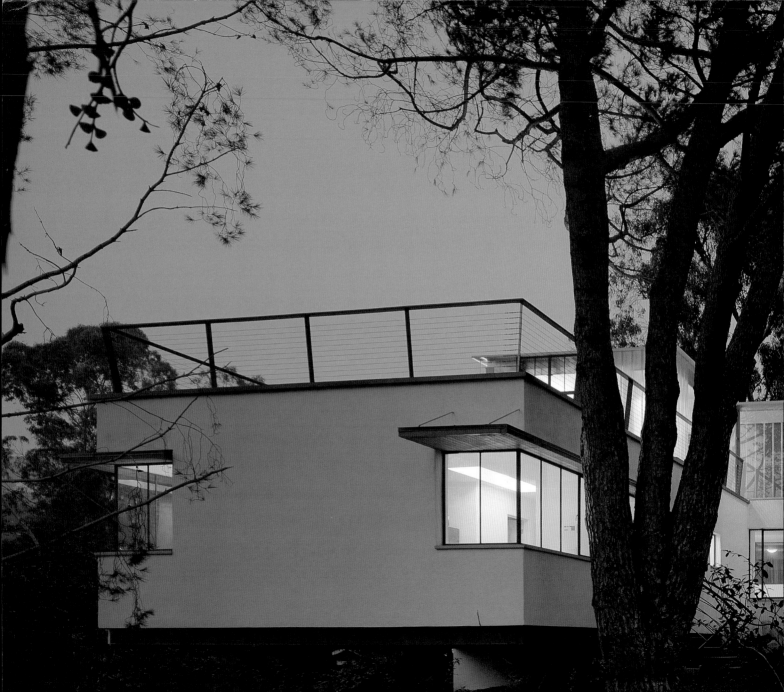

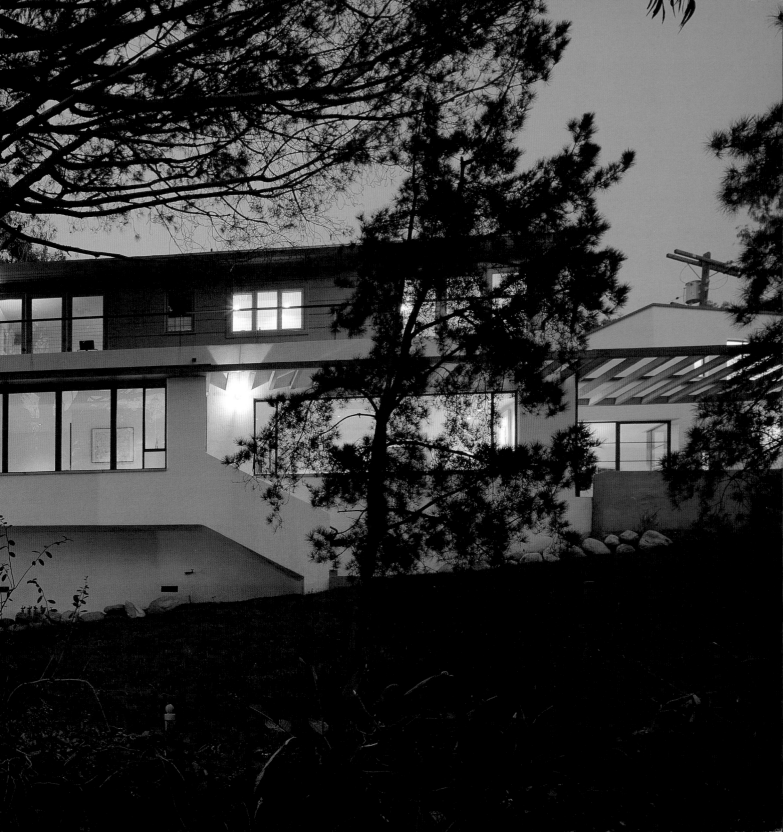

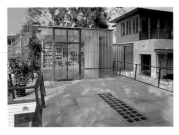

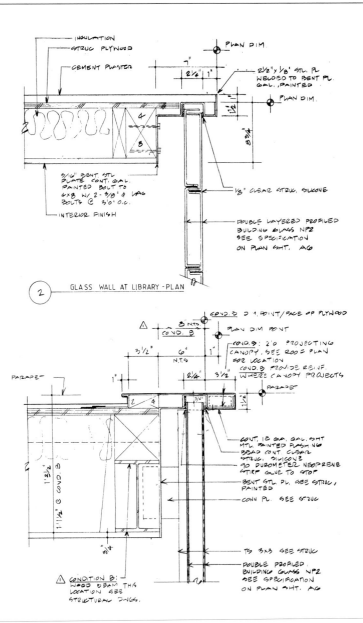

INSULATION
STRUC PLYWOOD
CEMENT PLASTER

PLAN DIM

7"
2¼" 1"

2½" x ⅛" STL. PL.
WELDED TO BENT PL.
GAL. PAINTED

PLAN DIM.

8¼"

3/16" BENT STL
PLATE CONT. GAL.
PAINTED BOLT TO
4x8 W/ 2-⅜" Ø LAG
BOLTS @ 3'0" O.C.

INTERIOR FINISH

⅛" CLEAR STRUC. SILICONE

DOUBLE LAYERED PROFILED
BUILDING GLASS NP2
SEE SPECIFICATION
ON PLAN SHT. A6

② GLASS WALL AT LIBRARY - PLAN

COND. B @ JOINT/FACE OF PLYWOOD

3" N.T.S.
COND. B

PLAN DIM POINT

COND. B: 2'0 PROJECTING
CANOPY SEE ROOF PLAN
FOR LOCATION

3½" 6" 1"
N.T.S.

COND. B PROVIDE REINF.
WHERE CANOPY PROJECTS

PARAPET

1"
2¼" 3½"

PARAPET

2" 4"

CONT. 18 GA. GAL. SHT
MTL. PAINTED FLASHING
BEAD CONT CLEAR
STRUC. SILICONE
90 DUROMETER NEOPRENE
STRIP GLUE TO STOP
BENT STL. PL. SEE STRUC.
PAINTED
CONN PL. SEE STRUC

13½"

1'1½" @ COND. B

TS 3x3 SEE STRUC

DOUBLE PROFILED
BUILDING GLASS NP2
SEE SPECIFICATION
ON PLAN SHT. A6

⅜"

△ CONDITION B:
WOOD BEAM THIS
LOCATION SEE
STRUCTURAL DWGS.

The new bedroom and library addition "hovers" over the descending hillside. By slipping the channel glass planes past the structural frame, the library takes on an extremely lightweight quality, only exposing a very thin roof, floating above glass.

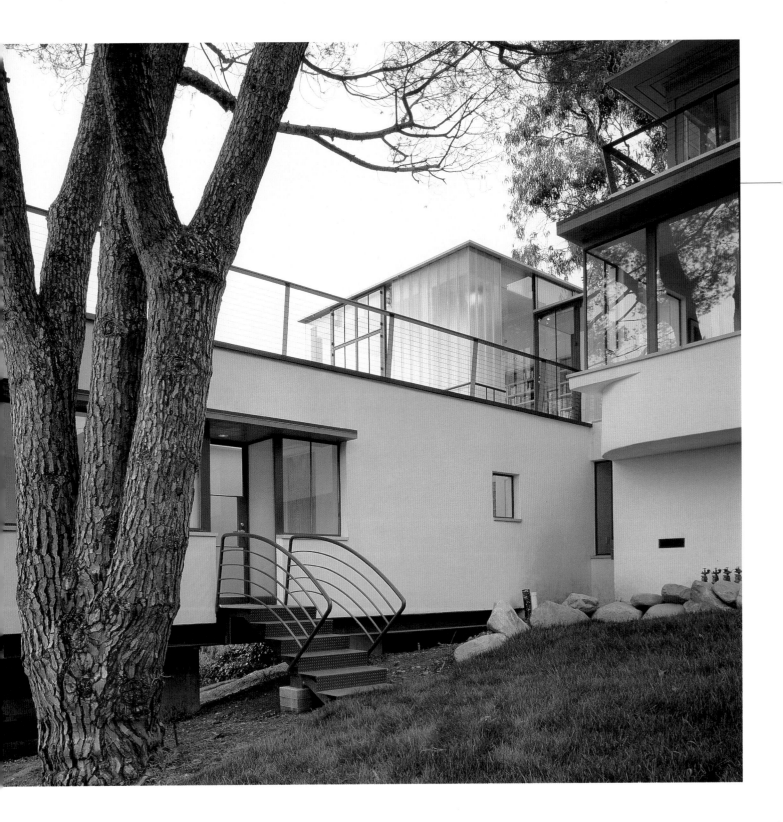

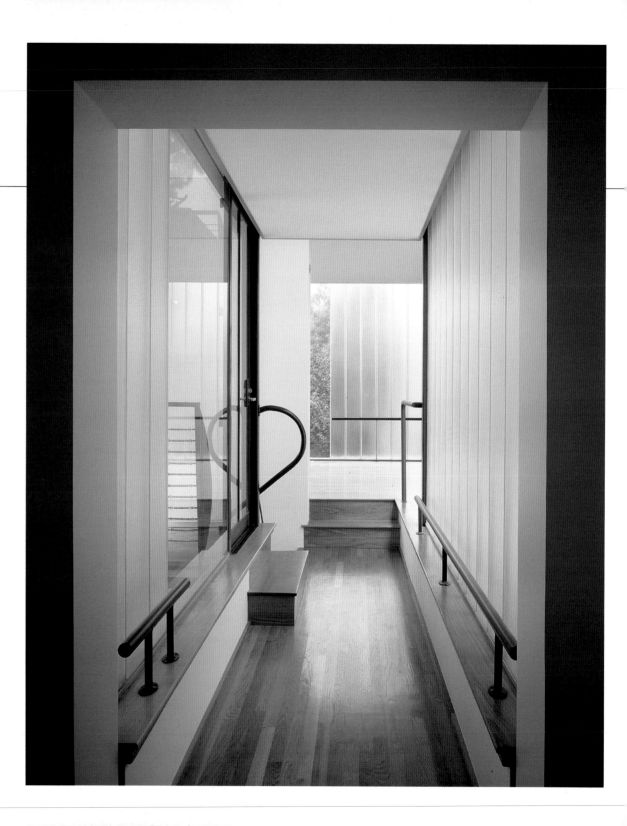

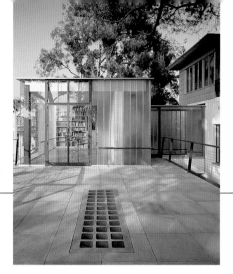

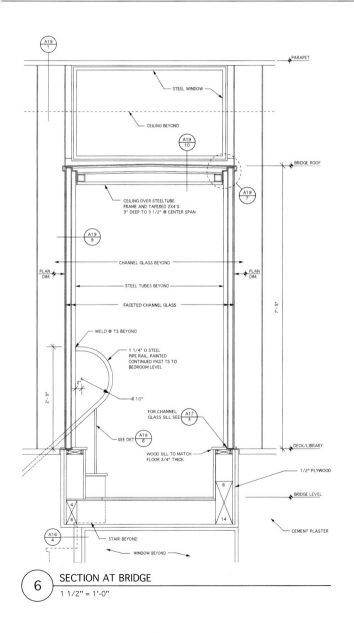

PARAPET

STEEL WINDOW

CEILING BEYOND

BRIDGE ROOF

CEILING OVER STEELTUBE
FRAME AND TAPERED 2X4'S
3" DEEP TO 3 1/2" @ CENTER SPAN

CHANNEL GLASS BEYOND

STEEL TUBES BEYOND

FACETED CHANNEL GLASS

WELD @ TS BEYOND

1 1/4" O STEEL
PIPE RAIL, PAINTED
CONTINUED PAST TS TO
BEDROOM LEVEL

R 10"

FOR CHANNEL
GLASS SILL SEE

SEE DET

WOOD SILL TO MATCH
FLOOR 3/4" THICK

DECK/LIBRARY

1/2" PLYWOOD

BRIDGE LEVEL

CEMENT PLASTER

STAIR BEYOND

WINDOW BEYOND

PLAN
DIM.

PLAN
DIM.

6 SECTION AT BRIDGE
1 1/2" = 1'-0"

View from the bridge connecting the
main house to the library (opposite).
One ascends a stairwell from the master
bedroom (bottom, middle) to arrive
at the library, which opens onto a roof
deck (above).

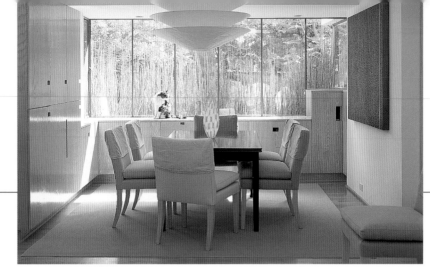

Ash cabinets provide storage in the dining room, while thin steel mullions match existing steel windows on the house and reflect the vertical lines of the exterior landscape of Horsetail (top). Sitting area facing outdoor views (middle). A mitered glass corner in the bedroom makes a connection to the exterior by accommodating the location of an existing pine tree (below). The living room focuses on a minimalist green slate fireplace (opposite).

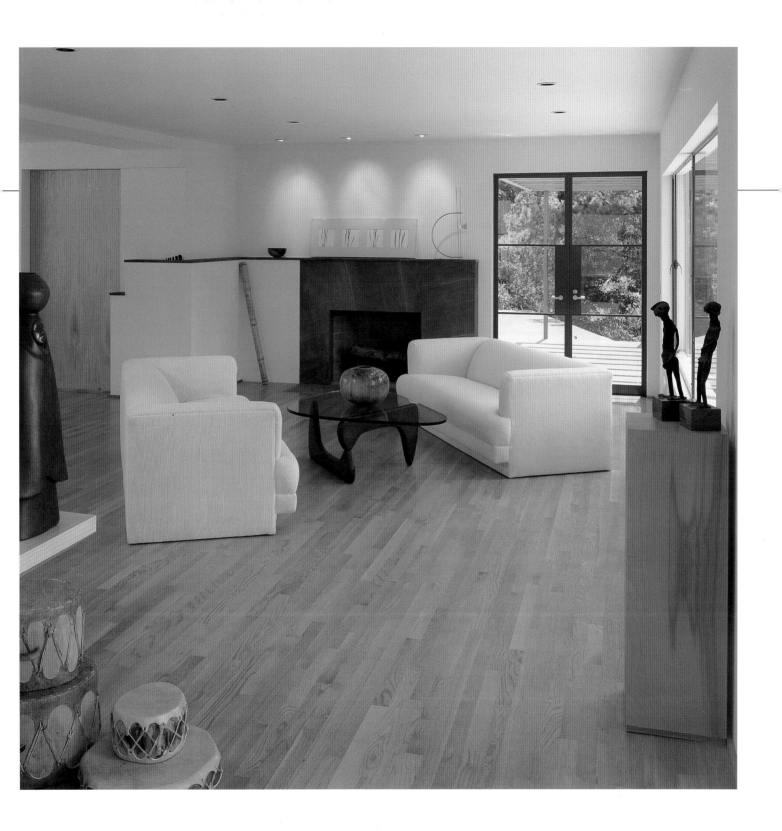

Bernard Residence

MALIBU, CALIFORNIA

Set on a hillside overlooking the Pacific Ocean and the expansive Santa Monica Mountains, the Bernard Residence celebrates the interaction between building and landscape. The house is integrally tied to the landscape in siting and orientation yet is in juxtaposition to the landscape with its simple planar volumes and modernist, white architecture.

Specific relationships between the project and the site play a critical role in the building's design. The siting of the bedroom wing toward the canyon responds to a desire for silence and privacy, while the living spaces enjoy an expansive view of the coastline The house itself is partially engaged in the earth at the private/bedroom end, then emerges out to cantilever over the sloping hillside at the public/living end.

The private wing is defined primarily by the upturned metal roof, permitting clerestory light into the rooms. The public wing, however, has an open plan and is defined by an uninterrupted curved wall that permits light and views through generous openings. Delicate steel and glass elements punctuate the plaster walls, not only celebrating the intrinsic qualities of materials but also serving to engage the interior space with the exterior.

Although distinct, the two wings overlap in many ways. The interior maple volumes, which define the wardrobes and bathrooms in the bedroom wing, wrap into the living space to become bookshelves. The metal roof over the bedroom wing extends into the kitchen and dining areas, and the use of steel canopies throughout the house serves to unite the two wings. This interlocking and engagement—between materials and plan elements, and between the house and landscape—continue the modernist tradition of California.

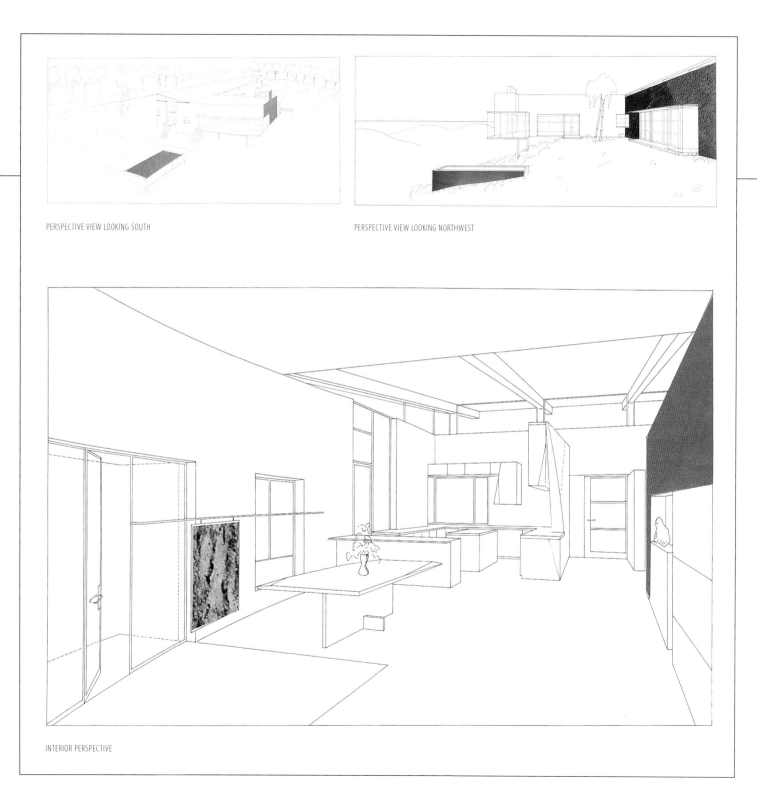

PERSPECTIVE VIEW LOOKING SOUTH

PERSPECTIVE VIEW LOOKING NORTHWEST

INTERIOR PERSPECTIVE

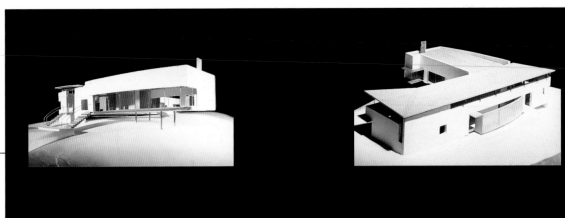

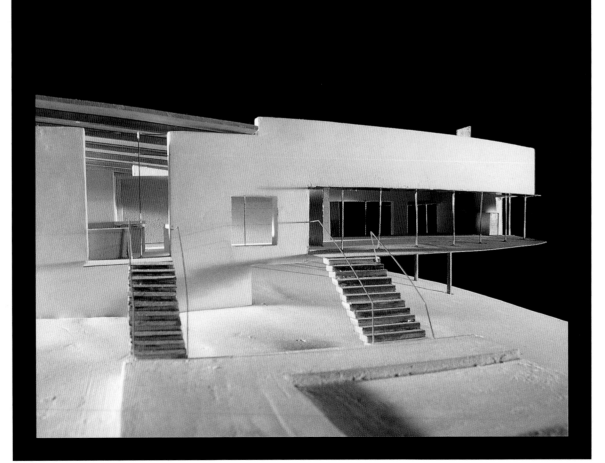

The house is partially engaged with the earth at the private bedroom end, then cantilevers out over the sloping hillside at the public/living end. An uninterrupted curved wall defining the public/living room permits light and views with generous openings (opposite). The private wing is defined by an upturned metal roof, creating a clerestory which illuminates interior rooms.

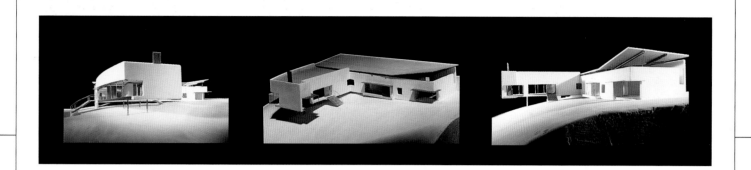

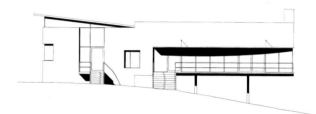

SOUTH ELEVATION

1. ENTRY
2. KITCHEN
3. DINING ROOM
4. LIVING ROOM
5. LIBRARY
6. OFFICE
7. POWDER ROOM
8. GARDEN
9. CORRIDOR
10. BATHROOM
11. BEDROOM
12. MASTER BEDROOM
13. MASTER BATHROOM
14. WARDROBE
15. GARAGE
16. STORAGE
17. PASSAGE
18. GUEST BEDROOM
19. LAUNDRY ROOM
20. WINE CELLAR

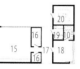

GARAGE/STUDIO PLAN

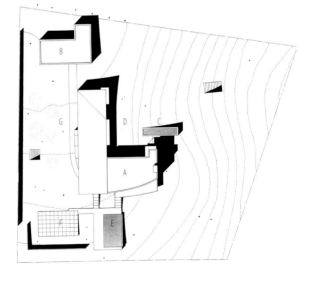

SITE PLAN

A. MAIN HOUSE
B. GUEST HOUSE/GARAGE
C. FOUNTAIN
D. COURTYARD
E. POOL
F. TERRACE
G. GARDEN

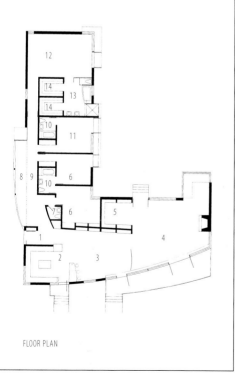

FLOOR PLAN

O'Herlihy Residence

MALIBU, CALIFORNIA

The design of the 3,400-square-foot (316-square-meter) O'Herlihy Residence aspires toward the simplicity and restraint of modernism, while it also celebrates the tactile quality of crafted materials. The house, which sits on a canyonside plateau with spectacular ocean and mountain views, ties to the landscape and is, at the same time, in direct contrast to it.

In order to take advantage of intimate canyon views and distant Pacific vistas from the nine-acre (four-hectare) site, the house is organized along two axes that intersect in the structure's entrance gallery. The principal, or canyon, axis begins at a low-walled parking area, extends along a sixty-six-foot (twenty-meter) vine-covered pergola, and passes through the house before terminating in a swimming pool pressed against the canyon's edge. Along the way is an irregularly shaped gravel courtyard—loosely enclosed by the house, a separate garage/guest room, and the sloping canyon—which catches the afternoon sun. The secondary, or ocean, axis traverses the living room, drawing one toward a ten-foot-square window that frames a coastal landscape.

The walls are fourteen inches (thirty-six centimeters) thick; this thickness was dictated by climatic consideration (the house keeps cool in the summer and warm in the winter and blocks hight winds) and the wish to "ornament" the chaste, white painted façade with deep window and door reveals.

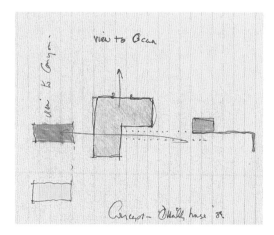

The interior and exterior spaces of the house interpenetrate, creating a continual dialogue with the natural surroundings. The thick plaster walls, tile floors, and beamed ceilings are rustic in character, yet reductive and refined in their execution. Thus, the house's studied simplicity responds to the local culture, climate, and topography.

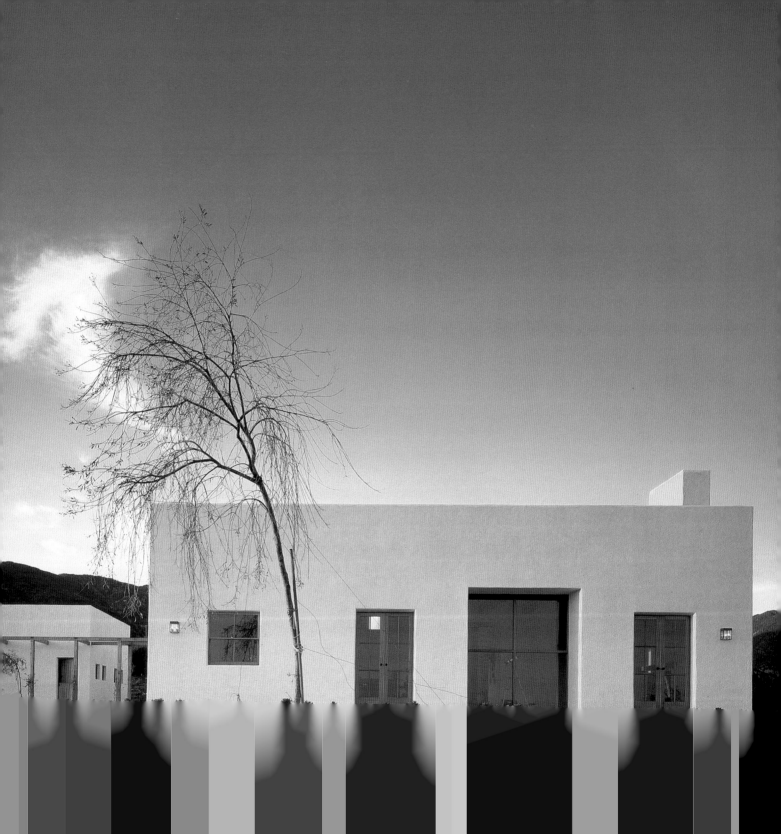

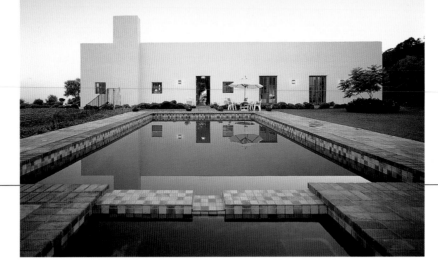

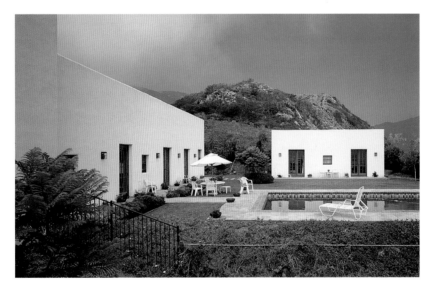

The swimming pool terminates the principal axis of the house, before the topography drops to the canyon below (above). The guest bedroom pavilion stands separate from the main house, contrasting the hillside views beyond (middle). The living and dining façade faces a path to an exterior garden (bottom).

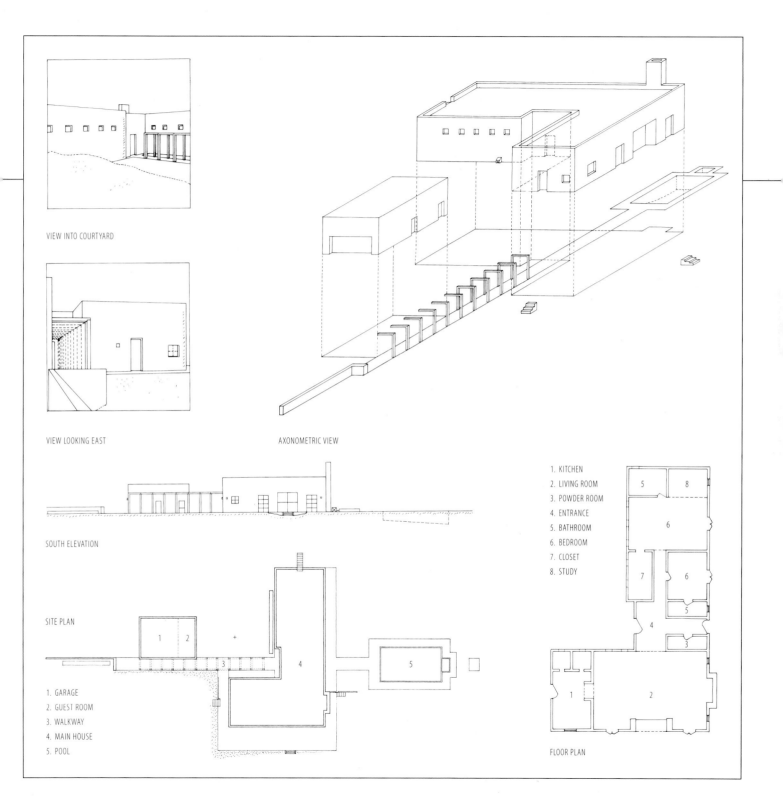

VIEW INTO COURTYARD

VIEW LOOKING EAST

AXONOMETRIC VIEW

SOUTH ELEVATION

SITE PLAN

1. GARAGE
2. GUEST ROOM
3. WALKWAY
4. MAIN HOUSE
5. POOL

1. KITCHEN
2. LIVING ROOM
3. POWDER ROOM
4. ENTRANCE
5. BATHROOM
6. BEDROOM
7. CLOSET
8. STUDY

FLOOR PLAN

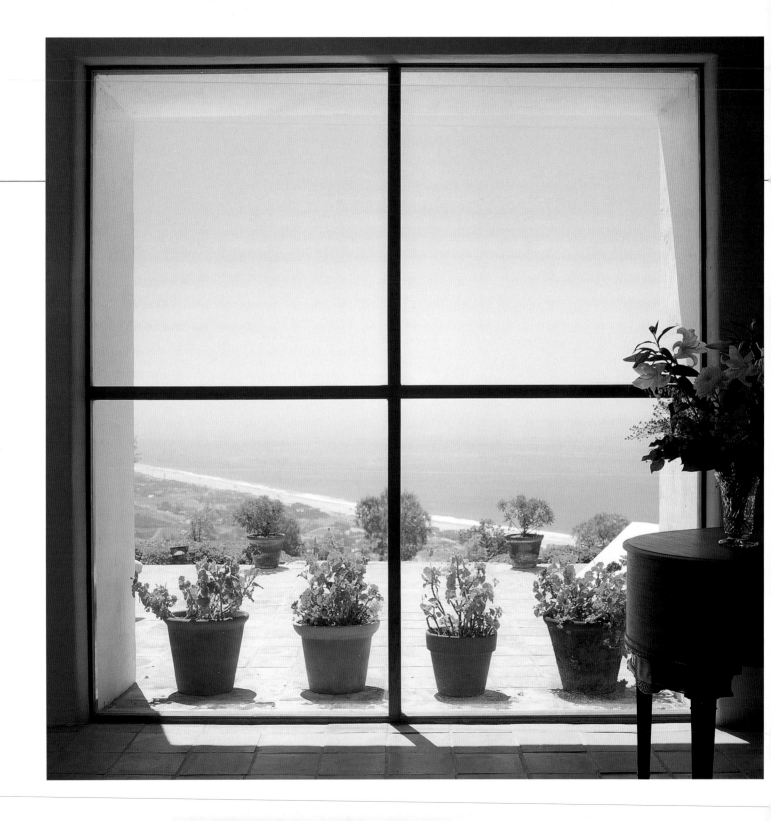

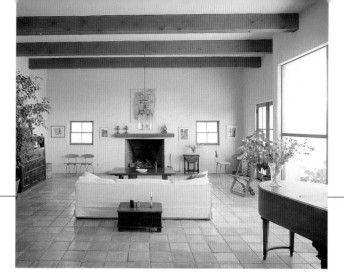

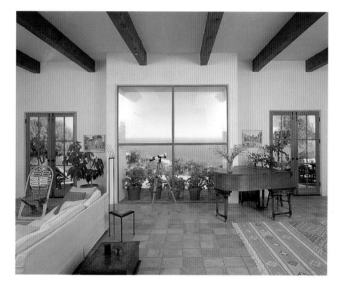

Exterior landscape and structure interpenetrate with the interior, creating a continuous dialogue with the natural landscape (opposite). Thick plaster walls, tile floors, and beamed ceilings are reductive and refined in their execution.

Commercial Works ▶

Delicatessen R&B

This project involved the renovation of a 750-square-foot (70-square-meter) office space located on a lot with a motel in Santa Monica. The clients, who manage the motel, wanted to open a small delicatessen to serve their guests and pedestrian traffic generated by its Main Street location. The task was to create an identity for the deli separate from the motel, while resolving the programmatic issues involved in putting a delicatessen in such a small space and on a rather limited budget.

The existing building was an anonymous stucco box completely dominated by its motel neighbor. The best way to give this little building an identity and presence on Main Street was to make it a completely rational, simple, white box. On the exterior O'Herlihy raised the front parapet and returned it at the top. This gave it a larger façade and a greater presence on Main Street, consistent with its neighbors, as well as a recognizable profile for those driving by. White ceramic four-inch (ten-centimeter) square tile was chosen as the exterior cladding, which reinforcing the concept and worked within our budget. This solution suggested a parallel with the diner aesthetic of the 1940s and 50s. Patina brass canopies protect a frameless glass curtain wall on the street facade and a nine-foot (three-meter) pivot door on the patio façade.

The interior of the project continues the "clean white box" theme but is overlaid with a "de Stijl" pattern of primary colors. Two major skylights "flood" the room with natural light, and in the evening the lighting continues the theme.

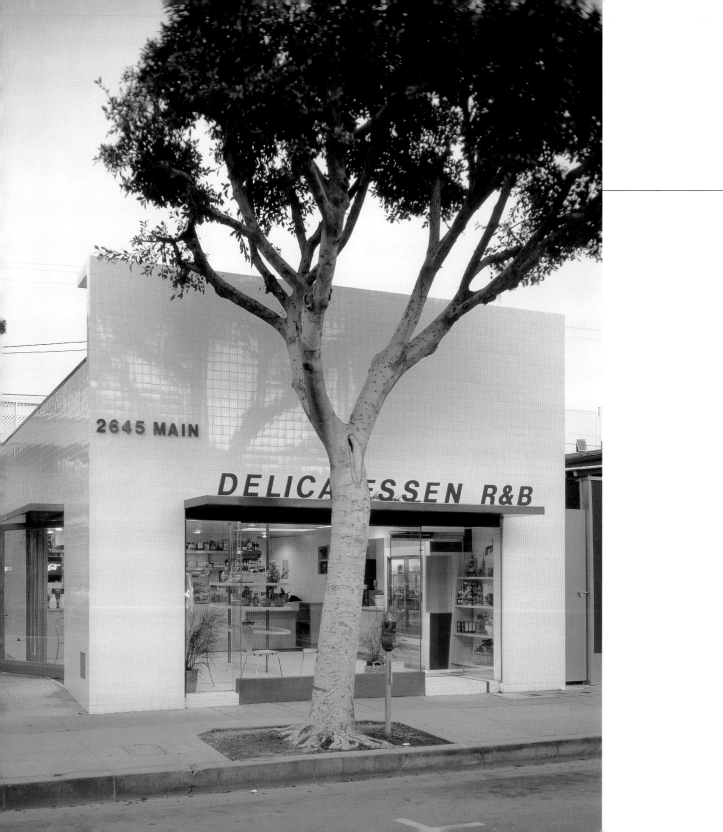

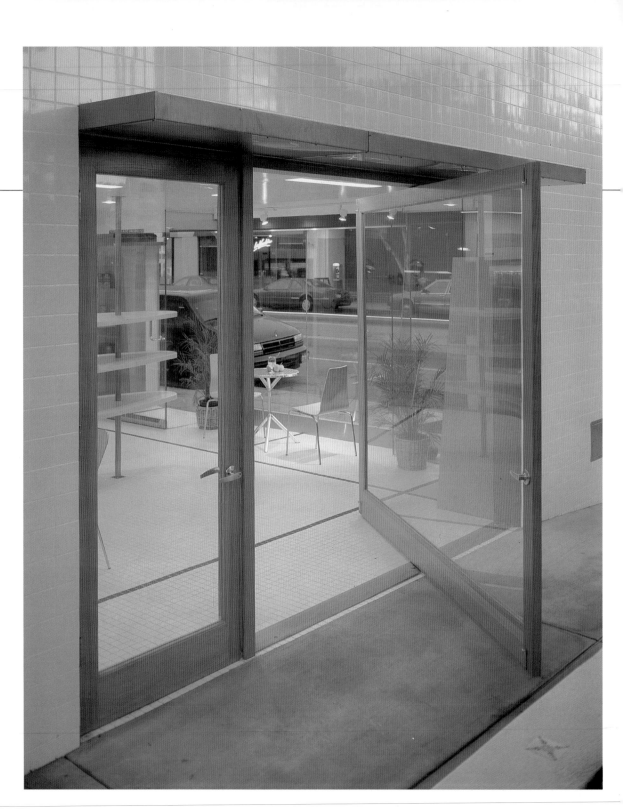

A large pivot door opens to an outdoor dining area. Extended roof parapet returns at the top to give the building a larger presence (opposite). The white façade is carried inside with de Stijl squares of primary color.

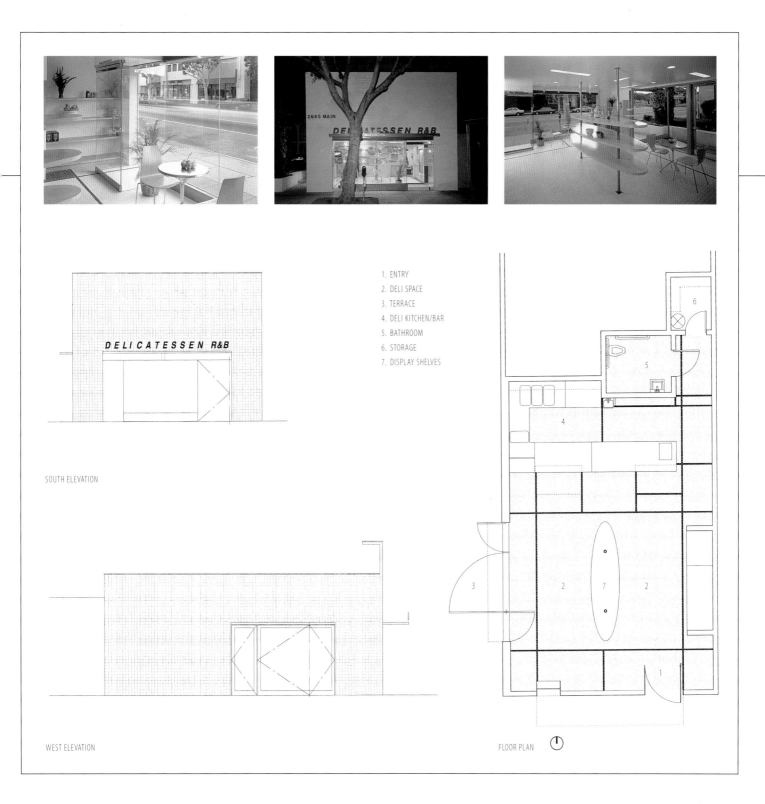

1. ENTRY
2. DELI SPACE
3. TERRACE
4. DELI KITCHEN/BAR
5. BATHROOM
6. STORAGE
7. DISPLAY SHELVES

DELICATESSEN R&B

SOUTH ELEVATION

WEST ELEVATION

FLOOR PLAN

Carmen's European Delicatessen

SANTA MONICA, CALIFORNIA

Charged with designing a European delicatessen in a space of 1,650 square feet (150 square meters), Lorcan O'Herlihy Architects searched for the clearest and simplest solution to solve the functional aspects of the project as well as giving the delicatessen a presence on Santa Monica's Main Street. By placing the support services (scullery, preparation, dry services, etc.) against the back wall, the public spaces open generously to the street by virtue of the aluminum window surround and marquee. The tables are positioned at the French windows to act as a device to encourage patrons to enter. The ceiling is painted a dark blue/gray to allow it to recede behind the birch soffit.

An individual standing on the corner of the delicatessen faces alternative forces of movement, the speed of the traffic on Main and the static of the parking lot. The wrapping aluminum window surround connects both façades. The folded aluminum awning acts as a counterpoint to the straight lines of the building, and extends the delicatessen into the public domain.

The design fully explores and celebrates the proportions and qualities of the space, creating a new and exciting presence on Main Street. Critical to the project was a simple geometry contrasting the clutter of retail shops around it. The blue color of the exterior works harmoniously with aluminum marquee.

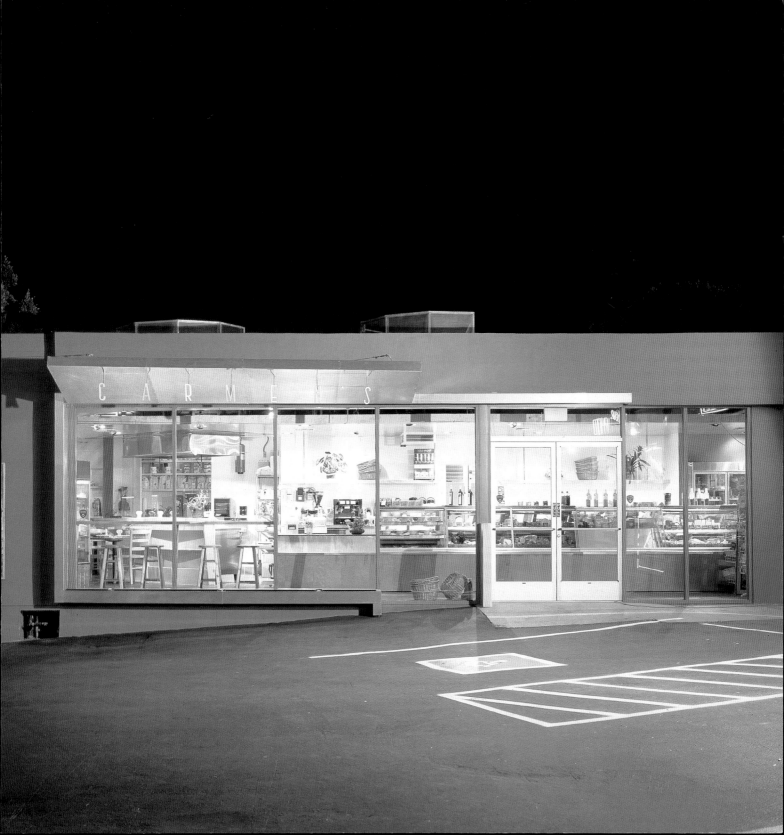

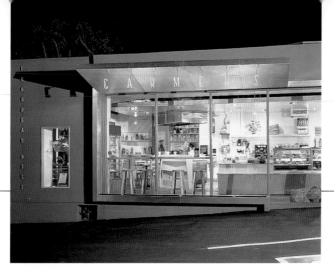

Carmen's European Delicatessen

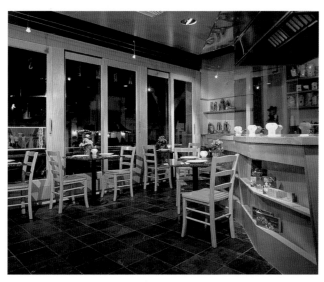

The folded aluminum canopy frames the
front entrance, exposing the interior
through glazing (top). Tables are placed
near the French windows to act as a
device to encourage patrons to enter
(middle). The birch soffit floats below
the dark blue/gray ceiling (bottom).
Aluminum letters hover on the street
façade, below a southwest facing
window canopy (opposite).

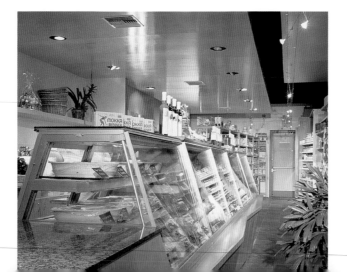

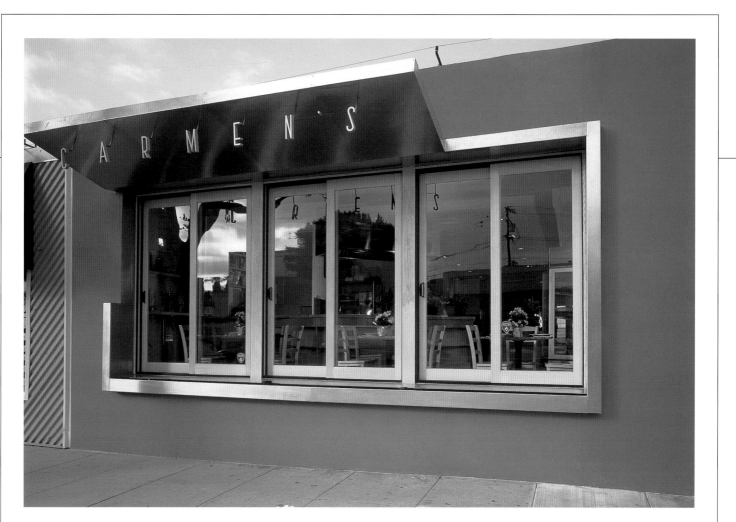

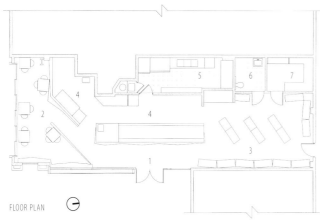

1. ENTRY
2. EATING AREA
3. DISPLAY SHELVES
4. DELI BAR
5. KITCHEN
6. BATHROOM
7. STORAGE

FLOOR PLAN

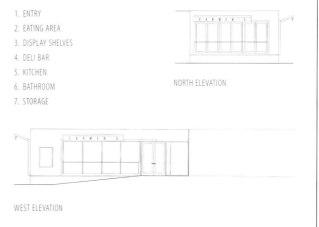

NORTH ELEVATION

WEST ELEVATION

Reform Showroom

The challenge was to design a showroom/production space within an existing 3,400-square-feet (316-square-meter) volume with a limited budget. The solution echoes the company's evolving theory of furniture design and fabrication. As per the client's request, Lorcan O'Herlihy designed the space, which then could be fabricated on-site. The simple interventions heeding the functional aspects were constructed from Baltic birch, painted drywall, and aluminum screens, thus exploring and separating the space as desired.

The unique challenge was to create the illusion that the main program was as a showroom, yet the production space utilizes half of the overall floor plan. The production space was hinted at by virtue of framed views in the floating walls.

The walls floated above the floor and below the ceiling, thus reducing the cost of demolishing much of the existing structure. Each intervention was considered a "dislocated piece" that worked with the whole but was equally autonomous. Much of the cabinetry could be disassembled afterwards, if the client decided to move to another space, and reassembled.

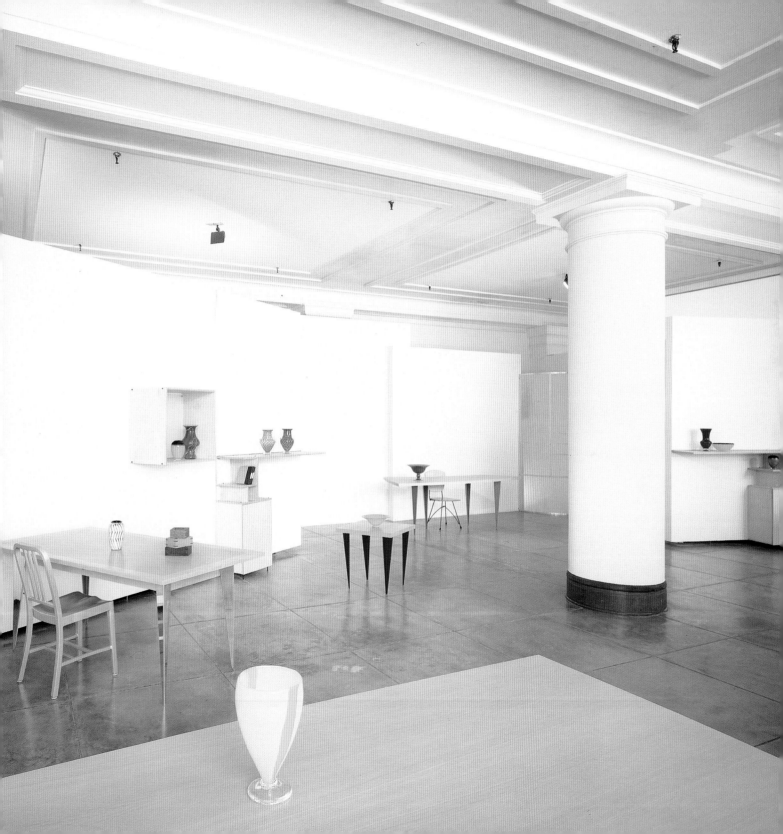

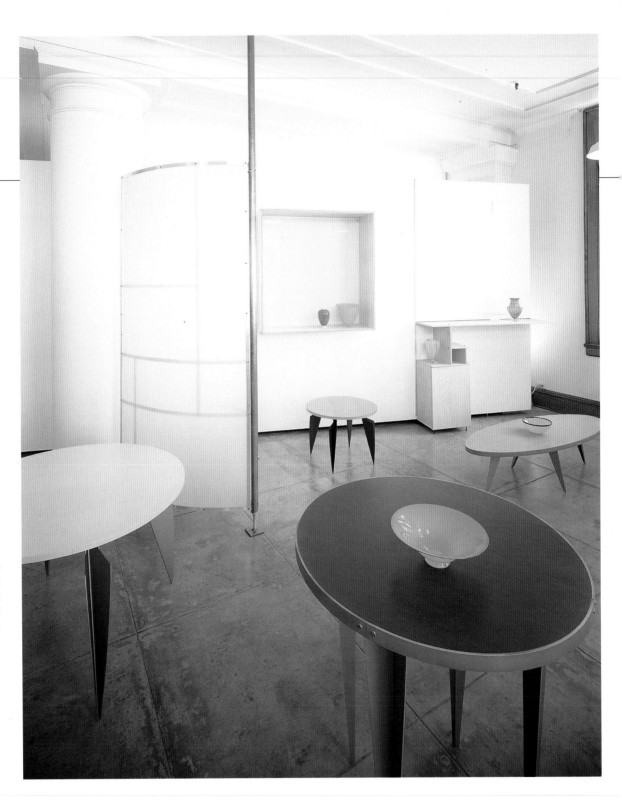

New walls hover above the floor while
aluminum screens attach to the existing
building at minimal points, reducing
demolition costs and allowing the owner
to relocate the pieces if necessary.

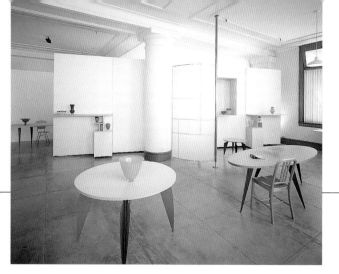

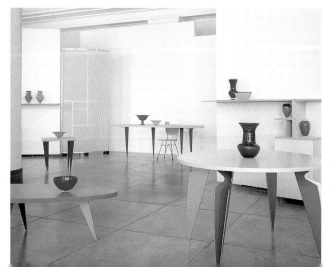

The space is divided into two production spaces and a large showroom. The walls floated above the floor and below the ceiling, thus reducing the amount of demolition required.

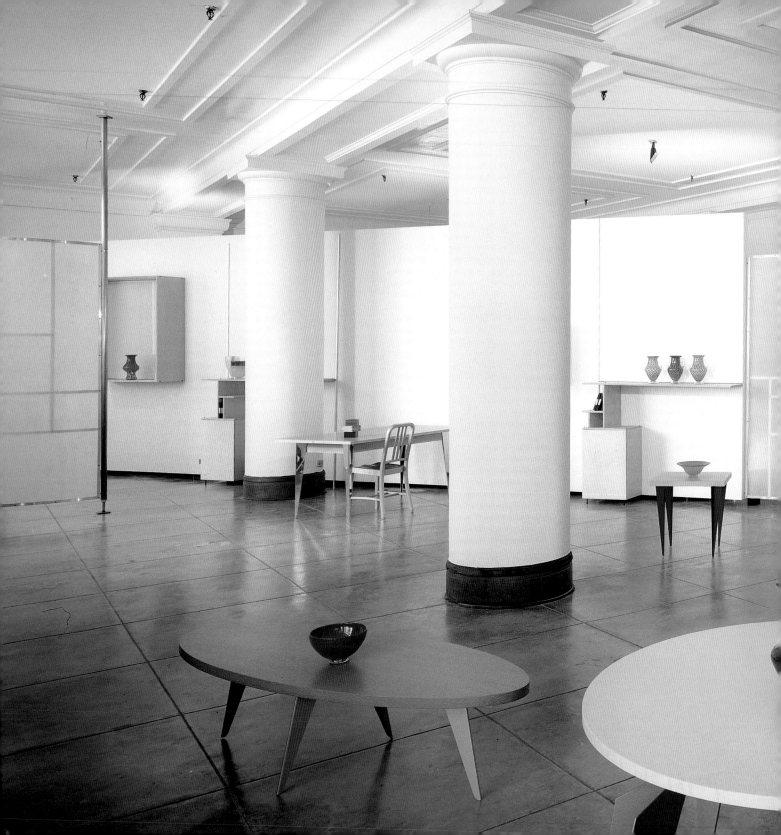

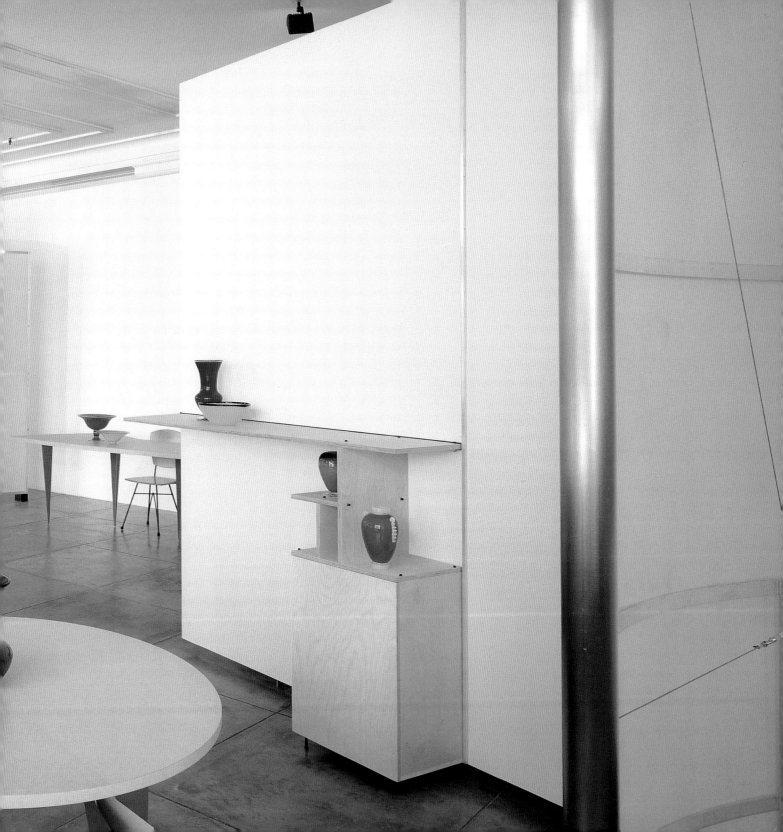

Harriet Dorn Women's Clothing Store

SANTA MONICA, CALIFORNIA

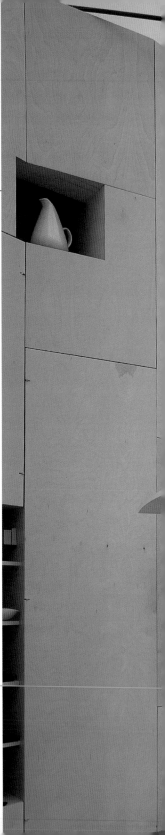

Located in Frank Gehry's Edgemar Development in Santa Monica, the Harriet Dorn women's clothing store shows just what can be done in tailoring a small space that is suffused with sunlight. The solution was to create an appealing retail interior in a two-hundred square-foot (nineteen-square-meter) trapezoidal space with a diameter of just twenty feet (six meters) and a height of fifty-two feet (sixteen meters).

Due to the compression of space, the architect developed a vertical plan that "led to the section as the primary generator of the architecture." Instead of a progression of rooms leading one to another, the architect established a series of stacked spaces reaching up to a skylight, which floods the room with sunlight. To filter this light, a nylon parachute hangs above the void. This solution lowers the ceiling to more manageable proportions but still suggests the vertical scale of the space. As many components as possible are suspended from above to leave the small concrete floor area clear. Adjustable plywood and metal clothes racks, for example, are hung from curved rods attached to the cross bracing-hot-rolled steel rods, five-eighths of an inch (sixteen millimeters) thick.

Along the back of the store, a folding wall of light birch plywood made by cabinet maker Steve Shelley provides exhibition and storage space as well as a changing room. Display shelves are also made of birch. Lighting is indirect: uplights mounted high on the walls reflect light off the nylon parachute; incandescent fixtures over the storage unit wash the back wall with light. The general effect is pleasingly distinctive, the combination of light birch, metal rods and translucent fabric in the store providing a sense of enclosure without claustrophobia. The constraints of the budget—just $8,000 —matched the smallness of the space, but the breadth of vision can be turned on its side and sent skyward.

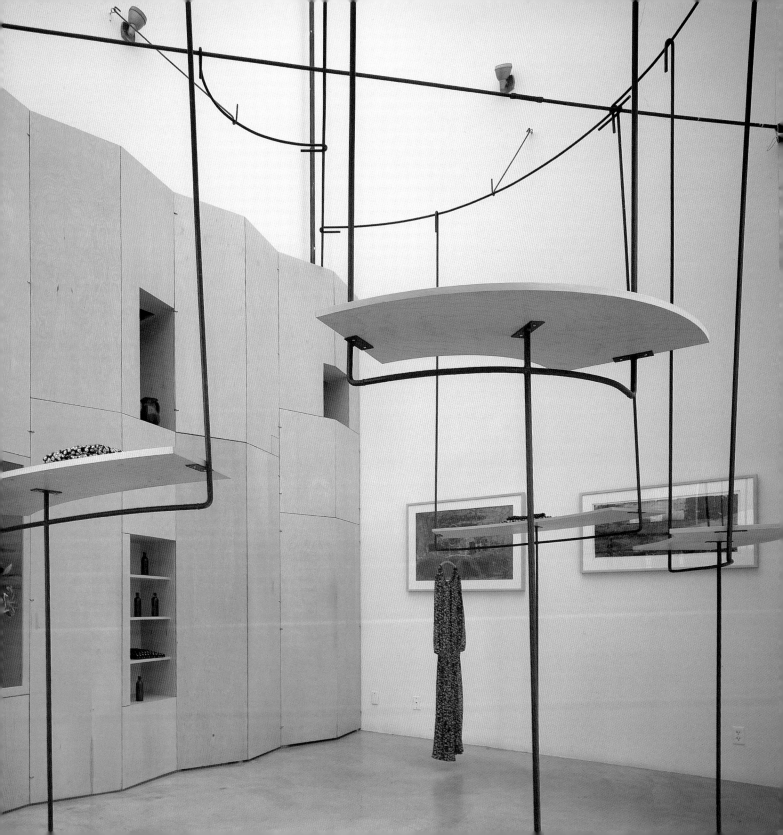

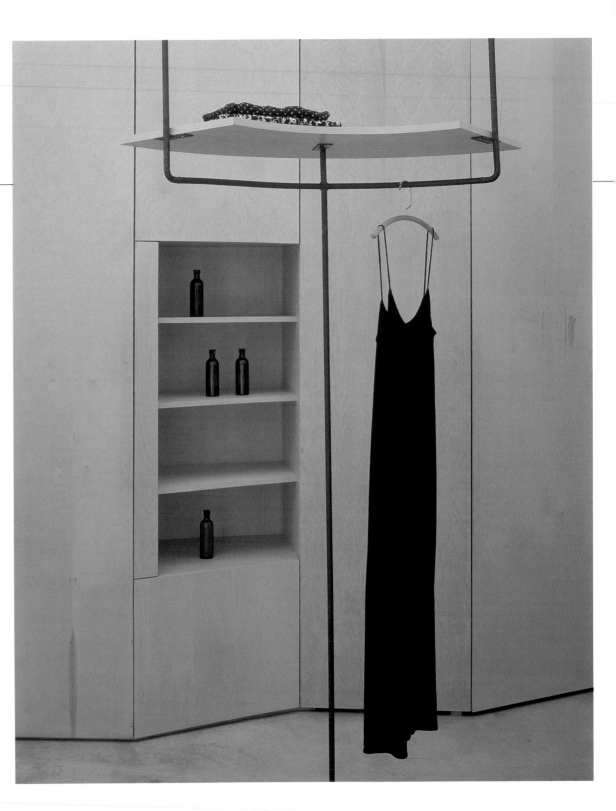

A network of metal clothes racks, moveable on curved rods, are counterpointed by a folding birch wall. Detail of curved rods and images reflecting the vertical and circular nature of the scheme to mitigate the constrained space (opposite).

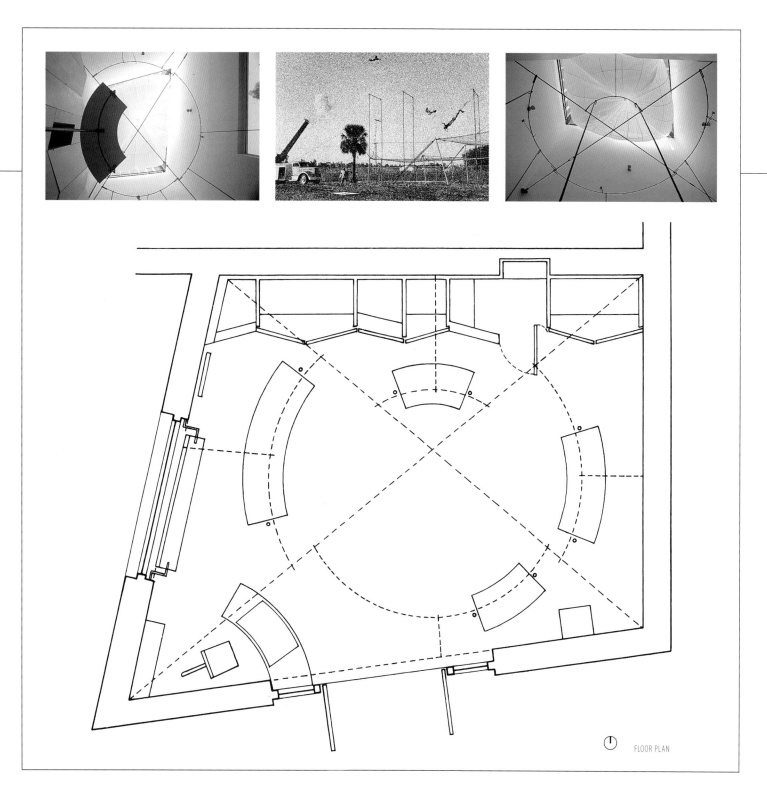

FLOOR PLAN

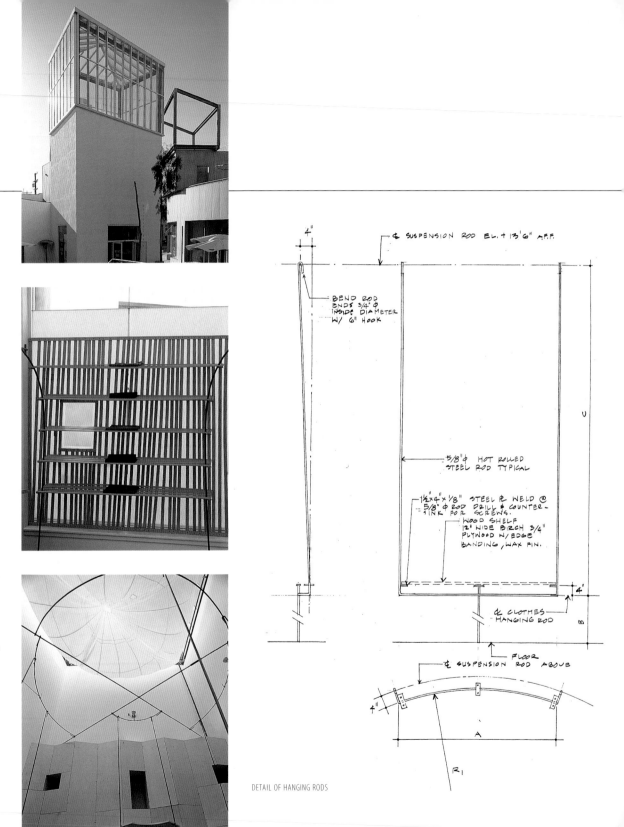

A series of stacked spaces reach up toward a sun-filled skylight spanned by a nylon parachute. Due to the limited space available, a vertical plan was "introduced", thus creating a visually larger space by virtue of drawing the eye upward.

DETAIL OF HANGING RODS

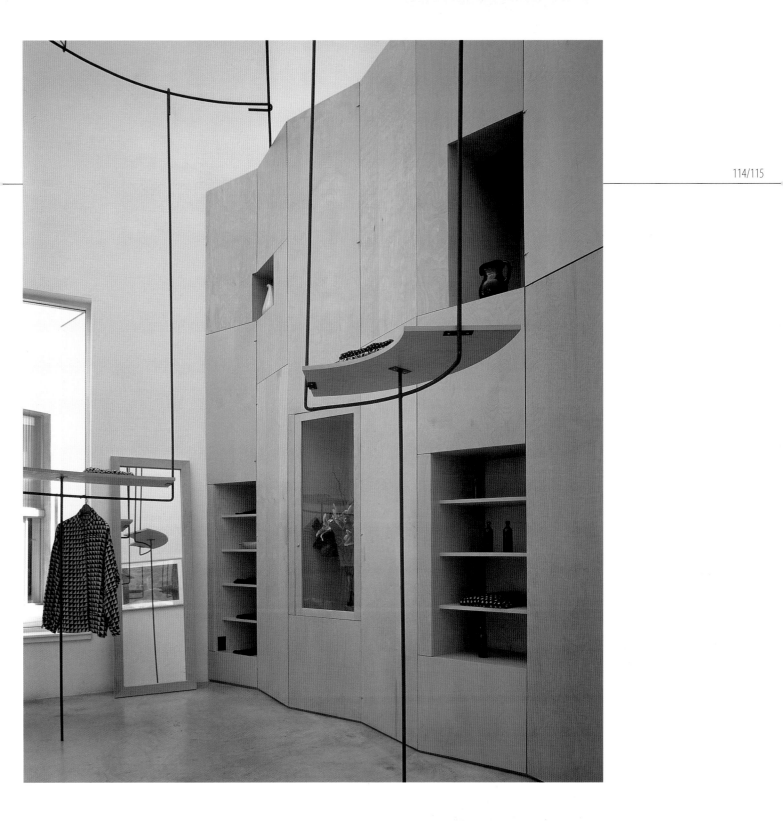

Julie Rico Gallery

SANTA MONICA, CALIFORNIA

This project celebrated the use of planes of refracted light to both draw people into the gallery and to display art. It served the needs of the gallery—to both reflect on society and to be consumed by it. Santa Monica (and Los Angeles in general) has become a very important art community; the request of the client was to create a unique façade which would give the gallery an important presence and encourage patrons to come in and see the Chicano art being exhibited.

As opposed to a conventional façade of flat planes of glass and a minimal statement, the client requested a façade of "movement." This was achieved both in plan and section by tilting the planes to provide for clearer vision into the gallery from outside. The oversized door was a functional device to allow for larger paintings.

The sectional quality of the façade created a space of transition from the street to the gallery. The gallery walls were positioned to blur the boundary between the art inside and the public outside.

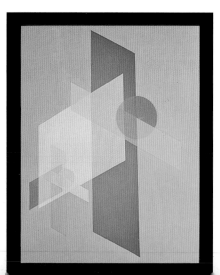

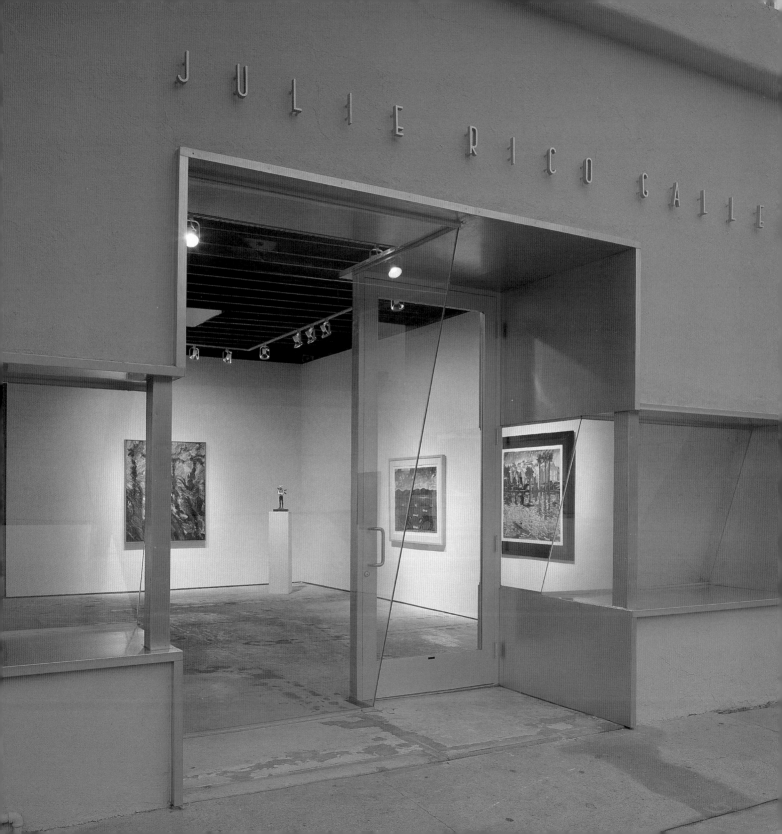

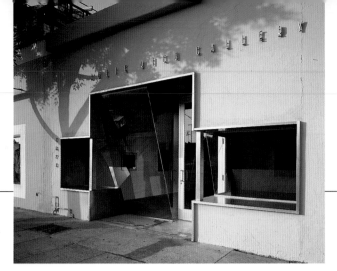

Julie Rico Gallery

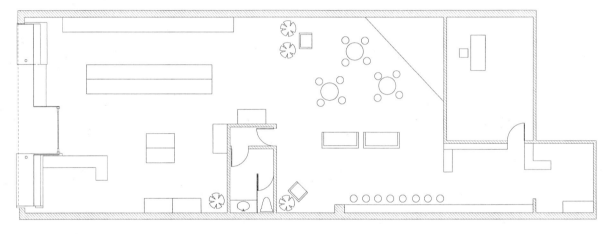

FLOOR PLAN

The façade of "movement" is achieved
both in plan and section by the folding
of the glass planes. From the interior,
the façade becomes a sculptural event.

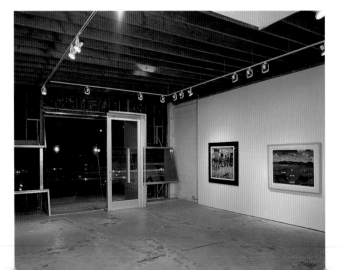

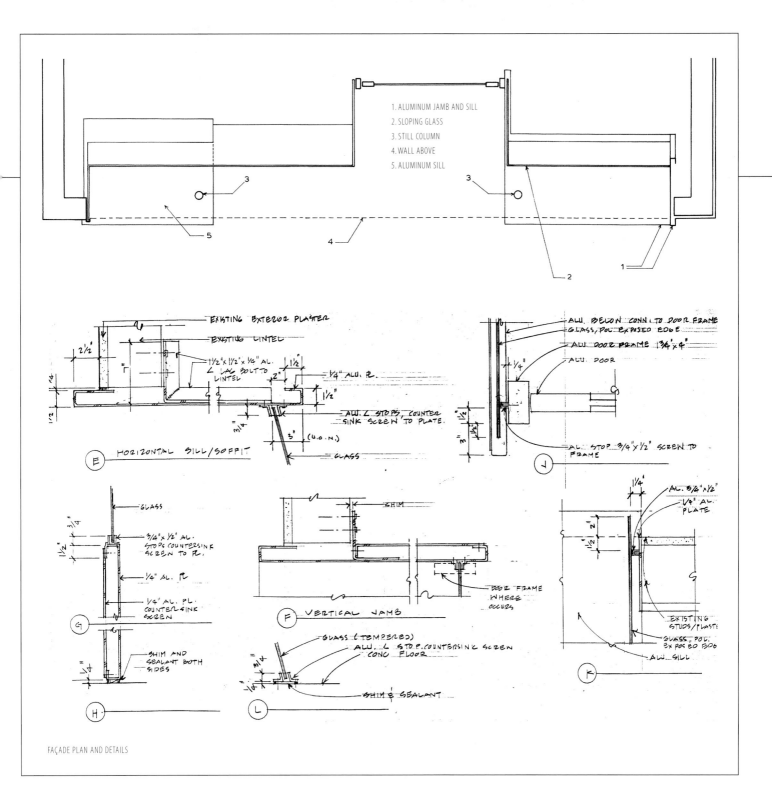

1. ALUMINUM JAMB AND SILL
2. SLOPING GLASS
3. STILL COLUMN
4. WALL ABOVE
5. ALUMINUM SILL

EXISTING EXTERIOR PLASTER

EXISTING LINTEL

1½" x 1½" x ¼" AL. L LAC BOLT TO LINTEL

¼" ALU. PL.

ALU. L STOPS, COUNTER SINK SCREW TO PLATE.

GLASS

E HORIZONTAL SILL/SOFFIT

ALU. BELOW CONN TO DOOR FRAME
GLASS, POL EXPOSED EDGE
ALU. DOOR FRAME 1¾"x 4"
ALU. DOOR

AL. STOP 3/4"x ½" SCREW TO FRAME

J

GLASS

¾"x ½" AL. STOPS COUNTERSINK SCREN TO PL.

¼" AL. PL

¼" AL. PL. COUNTERSINK SCREW

G

SHIM AND SEALANT BOTH SIDES

H

SHIM

DOOR FRAME WHERE OCCURS

F VERTICAL JAMB

GLASS (TEMPERED)
ALU. L STOP, COUNTERSINK SCREW
CONC FLOOR

SHIM & SEALANT

L

AL. ¾"x ½"
¼" AL. PLATE

EXISTING STUDS/PLASTER
GLASS, POL. EX POSED EDGE
ALU. SILL

K

FAÇADE PLAN AND DETAILS

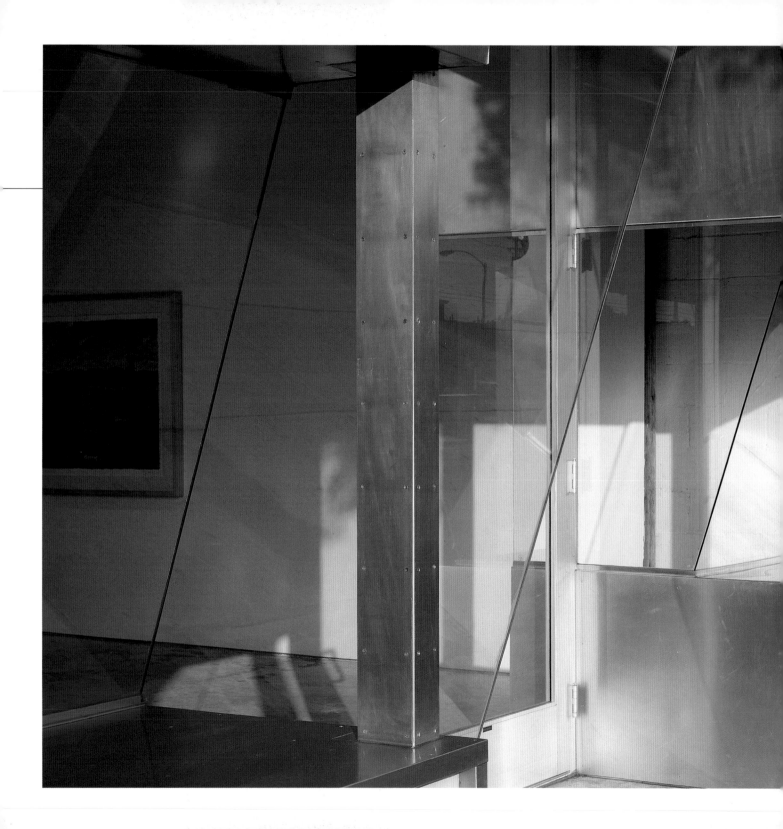

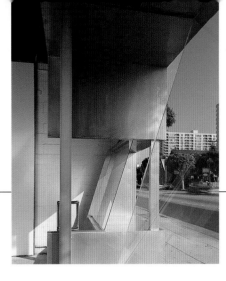

J U L I E R I C O G A L L E R Y

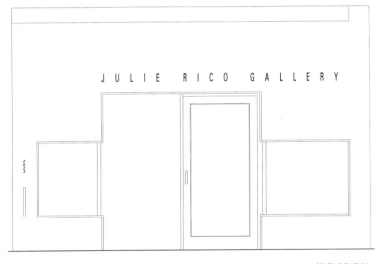

SOUTH ELEVATION

Folded aluminum façade allows for
sectionally dynamic entry and provides
a transition between the outdoor and
indoor worlds.

Video Production Office

Charged with renovating a 350-square-foot (33-square-meter) storefront space in Venice to house a video production office, the solution sought an architectural interpretation of the two-dimensional nature of film, the circumscribed vision of the camera and the frame-by-frame possibilities of the editing process. The design is a "landscape of singular elements," emphasizing surface treatments and sets up disparate scenes on opposite sides of the room. This is a symbolic reformation of modernism. The aim was to rethink certain building components, the furniture, and all finishes to come up with solutions that, however mindful of the materials' industrial origins and properties, are one-of-a-kind. The front door, installed to provide solid security, is made of sheet steel, whose hot-rolled, standard-width plates were allowed to weather individually before sealer was applied, rendering a variegated surface. The bent-rod handrail was tailored to the two-handed tugging motion required by the door's weight. Another example of "customizing the ready-made" may be found in the enhancement of the existing recessed can lights, which were shaded with new eighteen-inch (forty-six-centimeter) cylinders of aluminum mesh.

Consistent with the overall emphasis on crafted treatments, the vivid, painterly wall on one side of the office—created by Lorcan O'Herlihy—was conceived as a canvas. A dry roller supplied uneven densities of paint as it revolved, applying a first coat of blue, followed by a single coat of yellow.

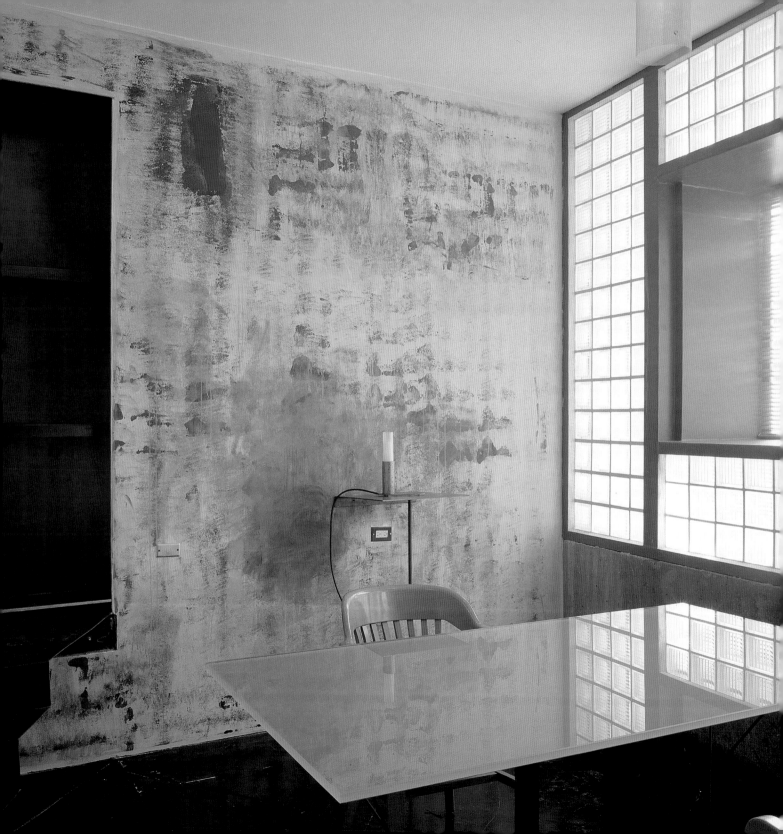

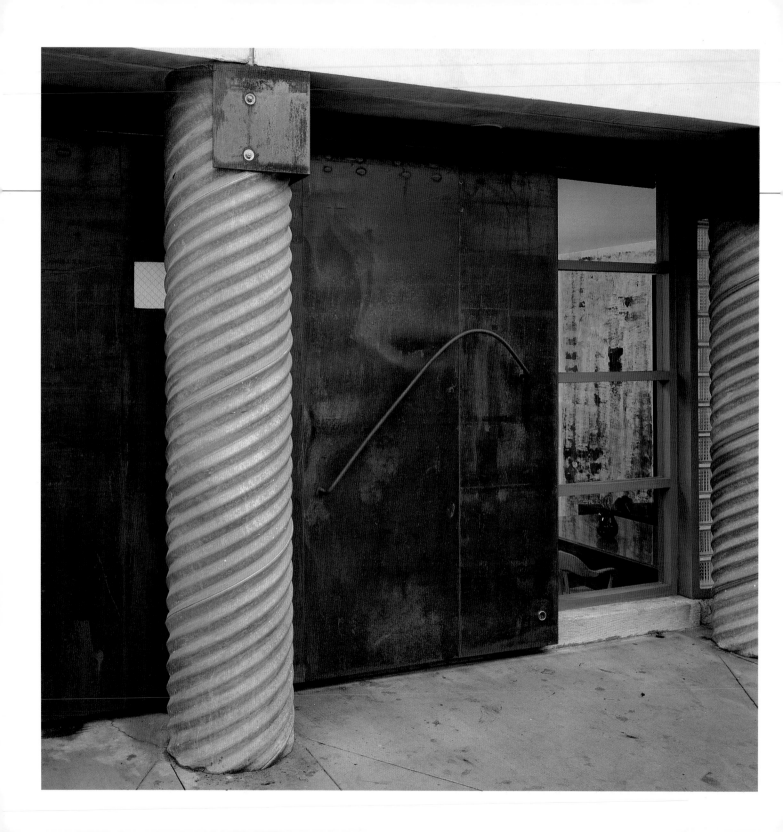

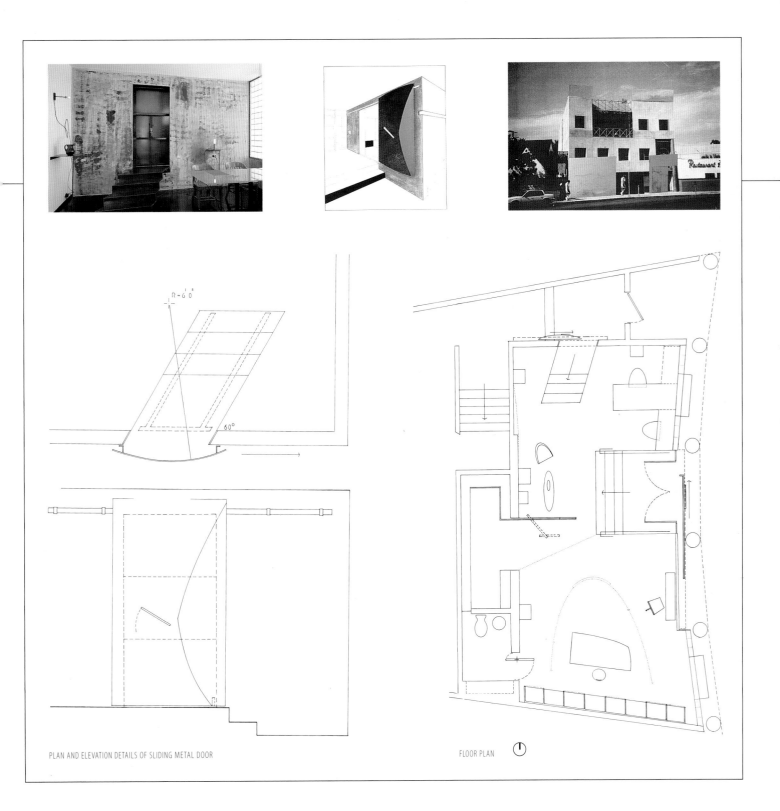

PLAN AND ELEVATION DETAILS OF SLIDING METAL DOOR

FLOOR PLAN

A transparent nylon curtain met the needs of a semi-private work area as did a custom screen, made of hinged plywood and sandblasted glass, which bisects the space. Corrugated Plexiglas panes reconfigure the otherwise bland wall of shelving.

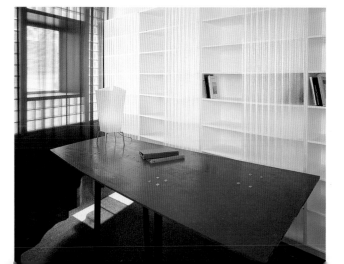

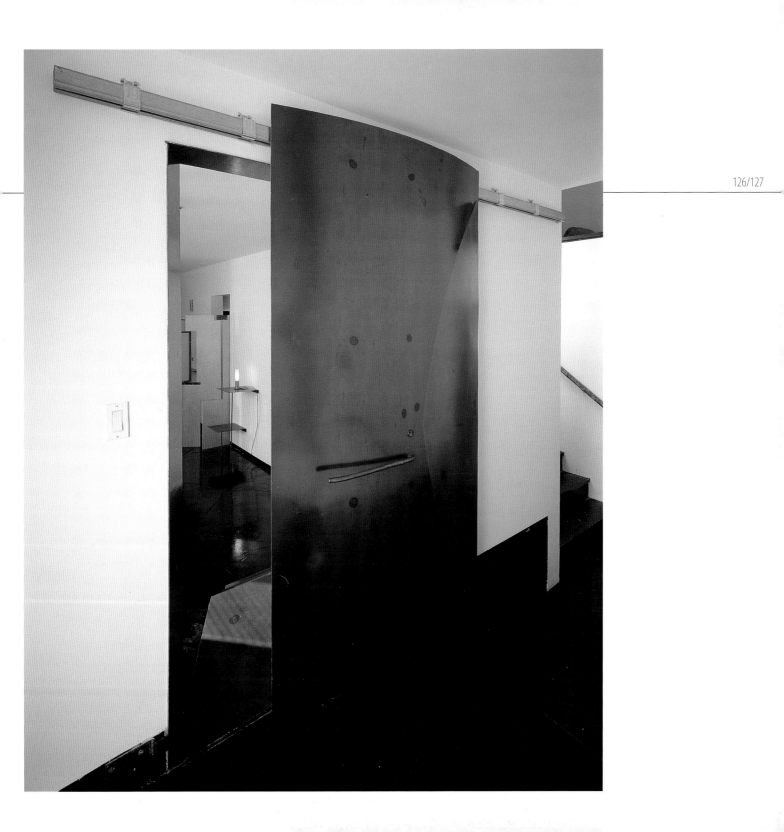

Selected Works ▶

Pasadena Armory Show

The two main spaces in Pasadena's Armory Center for the Arts are currently separated by a single high wall. The visitor is presented with the choice of being either a participant in the making of art (in the workshop) or a consumer of the artistic product (in the gallery), with little communication or acknowledgment of the interrelationship between the programs. The proposed Threshold Gallery seeks to make these relationships more permeable, exposing them to create a third programmatic space without detracting from either of the original functional aspects of the center. The Threshold Gallery acts as a central transition hall, an additional gallery (for the workshop participants), and generous entry into both spaces; the programmatic connection is visually clear—thus breaking the barriers between the making of art and the showing of art. The transparent, canted resin-wall proposed on the workshop side is to be a collaborative work of art between the Armory's students, teachers, and the architect. Additionally, a catwalk between the balcony and the future classrooms on the second story proposes a similar relationship.

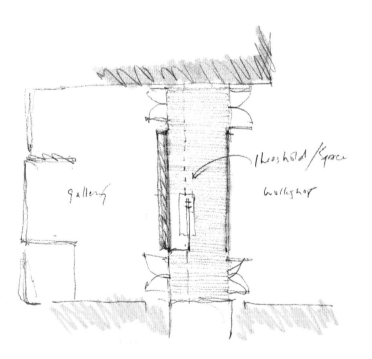

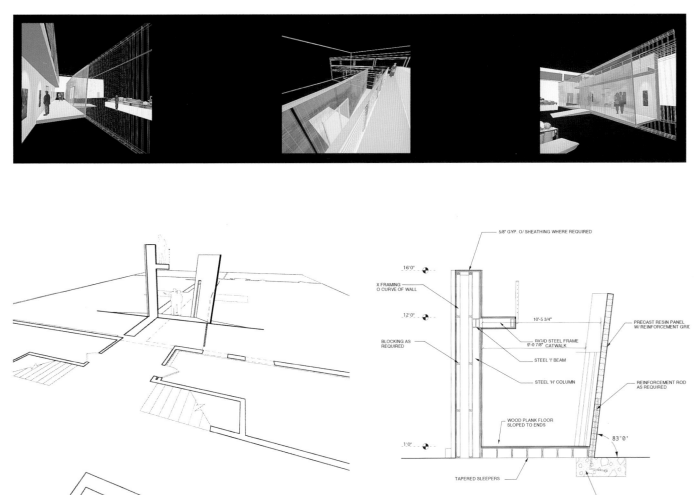

PLAN AND SECTION

THRESHOLD GALLERY

5/8" GYP. O/ SHEATHING WHERE REQUIRED

16'0"

X FRAMING
O CURVE OF WALL

12'0"

10'-5 3/4"

PRECAST RESIN PANEL
W/ REINFORCEMENT GRID

BLOCKING AS
REQUIRED

RIGID STEEL FRAME
9'-0 7/8" CATWALK

STEEL 'I' BEAM

STEEL 'H' COLUMN

REINFORCEMENT ROD
AS REQUIRED

WOOD PLANK FLOOR
SLOPED TO ENDS

1'0"

83"0'

TAPERED SLEEPERS

NEW CONCRETE FOOTING

Prado Museum Addition Competition

The design of an entry for the Prado Museum continues the contemporary exploration of dynamic spaces developed from the infinite space of modernism. The Prado project creates new spatial conditions at the urban scale; the scale of the proposed building itself, while fulfilling the programmatic elements required by the brief and integrating the new building into the urban fabric, still takes into consideration the existing buildings.

To accomplish this goal, the scheme synthesizes two concepts: the creation of a linear event-flow diagram through the new spaces and a formal sectional idea in which the roofscape creates a major, public, urban space. The Prado Museum Addition is composed in a manner in which the main entrance, exhibition areas, lecture hall, departments, offices, workshops, cafeteria, conference hall, library, and shops are organized along a linear spine. Critical to the proposal is the creation of a public space located on the roofscape of the new building. This plane is lifted and permeated at locations where natural light is essential for those working below. Larger permeations occur in the areas that are not occupiable surfaces but simply act as light sources for the work spaces below. The public space created by the roof of the new building acts as a virtual object that appears to float over the new building. The solution also connects to the present Army Building and the Cason del Buen Retiro building by virtue of an underground corridor, which has light sources penetrating its roof, bringing natural daylight into the space. It is important to note that this proposal keeps intact the existing buildings except for relocating the departments, offices, workshops, cafeteria, conference hall, library, and shops in the new building, which will free up more exhibition space in the Villanueva Building for exhibition space. The proposed building extends into the cloisters of the Jeronimos ensemble while honoring the exterior but reworking the subsurface spaces to accommodate the museum's basic needs. The proposal keeps the Cloister fragments in their current location.

The building belongs to neither city or the museum, but integrates both into a new composite whole. The presentation of the art collections of a museum is not all that matters; the nineteenth-century museum was no more than a stage, without what might be termed backstage facilities. Since then, the fact that such facilities need just as much, if not more, space than front-of-house has been recognized. The abundance of material in the existing Prado museum should not be hidden away from people wishing to study it, or even to see it from pure curiosity. The proposed addition and renovation of the Prado represents an obvious opportunity to create a great museum that will celebrate both the artistic and institutional aspects of the museum.

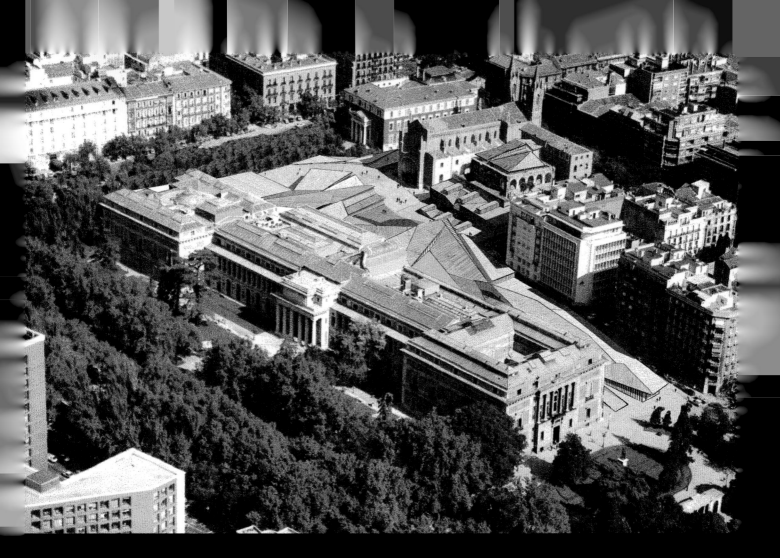

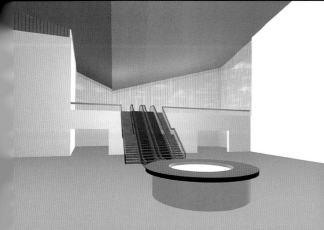

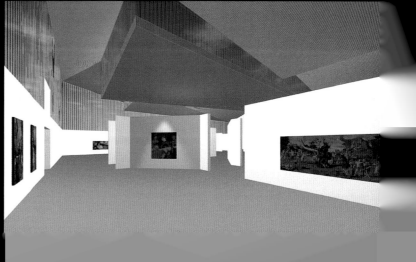

Furniture by Lorcan O'Herlihy

The subtle, intrinsic qualities of materials are expressed in their raw and unfinished state. Contrasting materials are juxtaposed against one another in harmonious tension: glass against steel; wood against leather. Minimal planes draw attention to the sincerity of the materials.

The simple planes of the furniture become an extension or elaboration of the space itself: the wall plane, floor plane, and ceiling plane. However, their integrity as minimal objects simultaneously contrast with the surrounding space. These objects respond to the methods of habitual behavior, to distance, to position, and to the comforts and convenience of domestic living.

The collection of furniture drew inspiration from the early modernist movement and its designers' interest in function and simple lines.

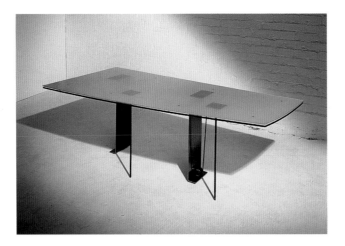

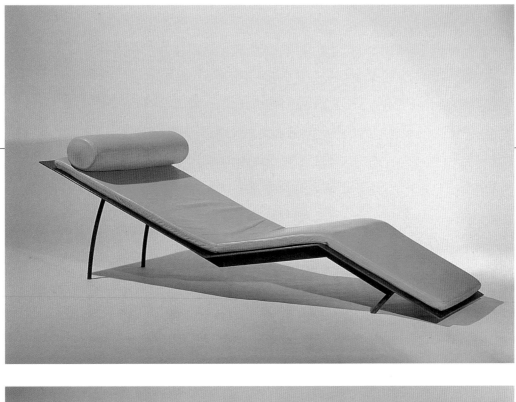

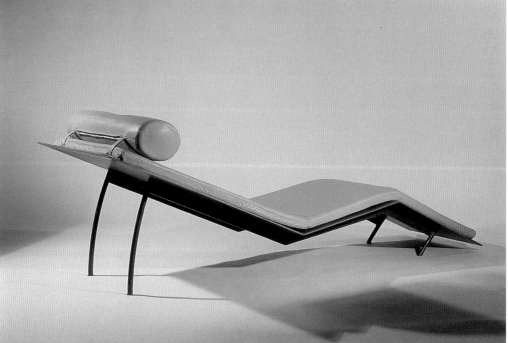

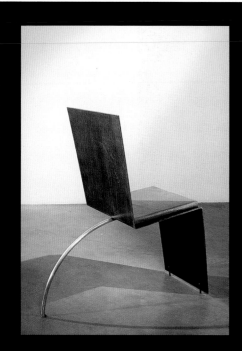
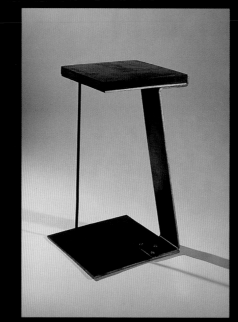

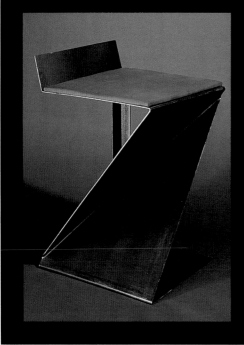
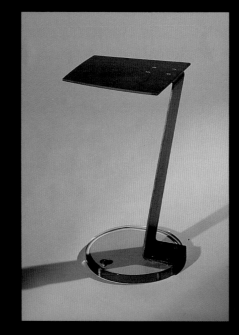
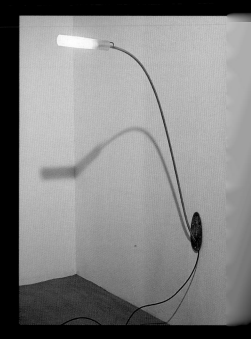

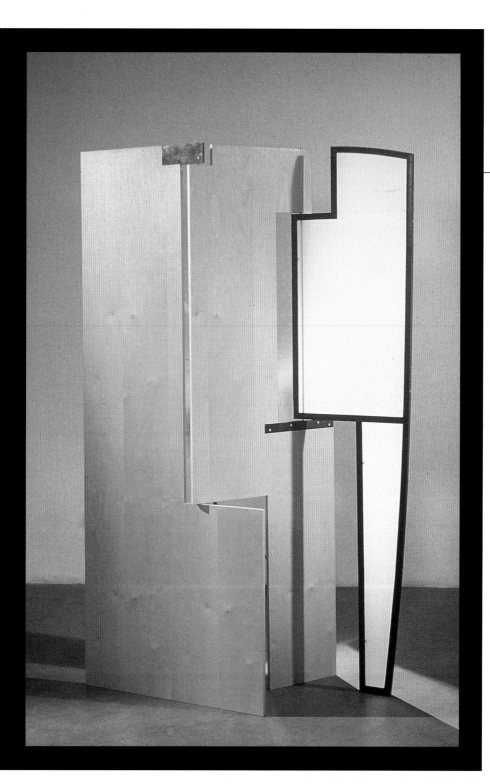

Folded steel planes reflect the intrinsic qualities of the materials used and continue the dialogue of the architecture they are housed in. The contrast of the materials—maple to sandblasted glass, leather to steel—continues O'Herlihy's interest in refined detailing, and how different textures can work together.

Paintings by Lorcan O'Herlihy

"What about the reality of the everyday world and the reality of painting? They are not the same realities. What is this creative thing that you have struggled to get and where did it come from? What reference or value does it have, outside the painting itself?"

Ad Reinhardt, 1950

The mission of Lorcan O'Herlihy's paintings is not to completely abandon the imitation of body and nature but to hover between figurative and non-figurative. The media he uses vary from spatula-applied impastos to drips and swirls, which reflect the balance in nature between continual control and spontaneous gesture.

Nature questions regularity. Despite the apparent simplicity of the laws that govern their formation, the works of nature are infinitely varied, whether they are great or small, and to whatever species or family they belong. The variety of form, color, mood, media, and composition in O'Herlihy's paintings create a buildup of the painting surface in low relief, thus expanding the gestural abstraction into three dimensions. The paintings are never solely aesthetic in intent but suggest a tracing of a story, which is in the mind of the viewer. Viewers bring whatever reality they choose.

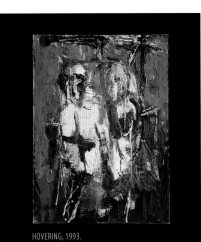

HOVERING, 1993.
Oil/acrylic on canvas, 36" x 48" (91cm x 122cm)

STUDY OF OBJECT IN LANDSCAPE, 1997.
Oil on canvas, 64" x 68" (163cm x 173cm)

UNTITLED VII, 1995.
Oil on canvas, 64" x 68" (163cm x 173cm)

MEDIA AND COMPOSITION, 1994.
Acrylic on canvas, 54" x 58" (137 x 147cm)

QUESTION NATURE, 1994.
Oil on canvas, 36" x 48" (91cm x 122cm)

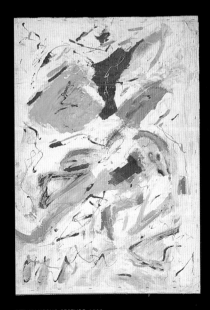

SPONTANEOUS GESTURE, 1998.
Acrylic on canvas, 36" x 48" (91cm x 122cm)

STUDY OF MOOD AND MEDIA , 1998.
Acrylic on canvas, 36" x 48" (91cm x 122cm)

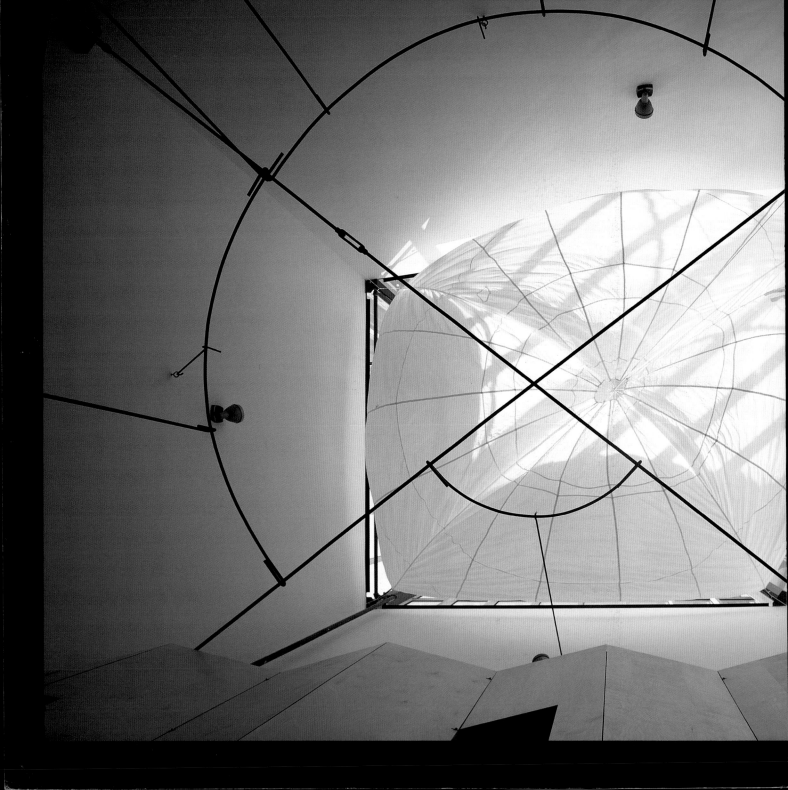

Appendix ▶

List of Works and Credits

KELLY RESIDENCE
Marina Del Rey, California 1997
Award: A.I.A./LA Honor Award
Architect: Lorcan O'Herlihy
Project Team: Vincent Lee (Project Architect), David Thompson,
Janice Shimizu, William Duncanson, Michael Poirier, Ricardo Diaz
General Contractor: Michael MacDowell
Structural Engineer: Sigma Design
Photography: Tom Bonner; Dominique Vorillon (pages 17, 22 top,
24, 25, 26 top middle); Lorcan O'Herlihy (page 27)

BECKSTRAND/GOLDHAMMER RESIDENCE
Palos Verdes, California 1997
Architect: Lorcan O'Herlihy
Project Team: Vincent Lee
Photography: Conrad Johnson

SPEEDWAY RESIDENCE
Venice California 1995
Architect: Lorcan O'Herlihy
Collaborator: Richard Warner
Project Team: Vincent Lee
Photography: Conrad Johnson

SINGLEDGE RESIDENCE
Kent, England 1995
Award: New Blood/101 Honor Award
Architect: Lorcan O'Herlihy
Project Team: Cornelius Hayes, William Duncanson
Consultant: Sarah Granville
Structural Engineer: Tony Gee and Partners
Photography: Cornelius Hayes; Cornelia Hayes O'Herlihy (page 42 top)

MEANEY ADDITION
Studio City, California 1995
Architect: Lorcan O'Herlihy
Project Team: Vincent Lee (Project Architect), Nida Chesonis
General Contractor: Stokx3 & Co.
Cabinetry: Soli-Craft
Structural Engineer: Nader Nohroodi and Associates
Photography: Grey Crawford (pages 44-46, 47 top left);
Dominique Vorillon (page 47 middle right)

GOLDHAMMER RESIDENCE
Manhattan Beach, California 1994
Award: GA Houses Projects 1999 Award
Architect: Lorcan O'Herlihy
Project Team: Molly Reid (Project Architect), Urs Britschgi, Vincent Lee
Structural Engineer: Parker Resnick
Landscape: Catherine Spitz and Associates
Photography: Conrad Johnson

ISLE OF MAN RESIDENCE
United Kingdom 1994
Architect: Lorcan O'Herlihy
Project Team: Urs Britschgi, Doug Macarag
Photography: Conrad Johnson; Lorcan O'Herlihy (page 61)

KLINE RESIDENCE
Malibu, California 1993
Award: *Progressive Architecture*, Houses Award
Architect: Lorcan O'Herlihy
Collaborator: Richard Warner
Project Team: Brad Maddalena, Phillip Ong, Mary Chou
General Contractor: Smith/Hammond
Structural Engineer: William Koh
CAD Consultant: Tim Campbell
Photography: Tom Bonner (pages 18, 62, 63, 64, 67, 68, 69, 70, 71);
Cornad Johnson (page 65, 66)

FREUND-KOOPMAN RESIDENCE
Pacific Palisades, California 1993
Award: *Progressive Architecture*, Houses Award
Architect: Lorcan O'Herlihy
Collaborator: Richard Warner
Project Team: Jennifer Jardine, Brad Maddalena, Chris Mercier
General Contractor: Chris Cowden
Structural Engineer: Miguel Castillo
Landscape: Nick Williams and Associates
Photography: Tom Bonner (pages 11, 72, 73, 76-81, 83); Jeremy Samuelson (page
16, 82); Conrad Johnson (pages 74, 75 right); Lorcan O'Herlihy (page 75 top middle)

BERNARD RESIDENCE
Malibu, California 1992
Architect: Lorcan O'Herlihy
Collaborator: Richard Warner
Photography: Conrad Johnson

O'HERLIHY RESIDENCE
Malibu, California 1990
Award: A.I.A./Western Home Awards; *Architectural Record* Honor Award,
Record Houses
Architect: Lorcan O'Herlihy
Structural Engineer: C. Brockmeier
Photography: Paul Warchol (pages10, 88, 89); Conrad Johnson (pages 90, 92, 93)

DELICATESSEN R&B
Santa Monica, California 1997
Architect: Lorcan O'Herlihy
Project Team: Vincent Lee (Project Architect), David Thompson,
Janice Shimizu, William Duncanson
General Contractors: Umberto Tripoli, Berni Lopez
Structural Engineer: Sigma Design
Photography: Conrad Johnson

CARMEN'S EUROPEAN DELICATESSEN
Santa Monica, California 1996
Architect: Lorcan O'Herlihy
Project Team: Vincent Lee, Molly Reid
General Contractors: Umberto Tripoli, Berni Lopez
Photography: Grey Crawford

REFORM SHOWROOM
Los Angeles, California 1996
Architect: Lorcan O'Herlihy
Consultants: Nancy Montgomery, Lawrence Schaffer
Photography: Conrad Johnson

HARRIET DORN WOMEN'S CLOTHING STORE
Santa Monica, California 1993
Award: *Architectural Record*, Record Interiors Award
Architect: Lorcan O'Herlihy
Collaborator: Richard Warner
Photography: Grey Crawford

JULIE RICO GALLERY
Santa Monica, California 1992
Architect: Lorcan O'Herlihy
Collaborator: Richard Warner
Interiors: Mario Madayag
Photography: Tom Bonner

VIDEO PRODUCTION OFFICE
Venice, California 1992
Award: *Progressive Architecture*, Interior Awards
Architect: Lorcan O'Herlihy
Collaborator: Richard Waner
Photography: Tom Bonner

PASADENA ARMORY
Pasadena, California 1996
Architect: Lorcan O'Herlihy
Project Team: Vincent Lee, William Duncanson, Geoffrey Ax
Photography: Lorcan O'Herlihy

PRADO MUSEUM COMPETITION
Madrid, Spain 1995
Architect: Lorcan O'Herlihy
Collaborator: Urs Britschgi
Project Team: Vincent Lee, Emily Jagoda, Phillipe Bonpas,
William Duncanson
Photography: Lorcan O'Herlihy

FURNITURE
Architect: Lorcan O'Herlihy
Collaborator: Richard Warner
Photography: Conrad Johnson

Lorcan O'Herlihy Architects, from left
to right: Molly Reid, Lorcan O'Herlihy,
David Thompson, William Duncanson.

ACKNOWLEDGMENTS

This publication would not be possible without the support and effort of Oscar Riera Ojeda and Rockport Publishers. In my architectural education and practice I have been fortunate to know many generous people who have inspired, educated, and helped me realize my work over the past years. My thanks to them all. I would particularly like to acknowledge Kevin Roche, I. M. Pei, Steven Holl, Vincent Lee, and my good friend Eric Kahn.

Special gratitude to those architects who have inspired me through their work: Luis Kahn, Mies van der Rohe, and Alvar Aalto. I am also very grateful to my clients who have trusted my vision and given me the opportunity to explore ideas with them.

With special thanks to my family and friends who have supported me through the best of times and worst of times.

This book is dedicated to my beloved wife Leila.